The VIS·ual Design

PRIMER

SUSAN G. WHEELER
GARY S. WHEELER

Prentice
Hall

Upper Saddle River, New Jersey 07458

Library of Congress Cataloging-in-Publication Data

Wheeler, Susan G.
 The visual design primer / Susan G. Wheeler, Gary S. Wheeler.
 p. cm.
 Includes index.
 ISBN 0-13-028070-4
 1. Commercial art--Vocational guidance--United States 2. Design--Vocational
 guidance--United States. I. Wheeler, Gary S. II. Title.

 NC1001 .W48 2002
 741.6'023'73--dc21 2001034353

Publisher: Bud Therien
Production Editor: Harriet Tellem
Prepress and Manufacturing Buyer: Sherry Lewis
Editorial Assistant: Wendy Yurash
Cover Design: Kiwi Design

This book was set by the author in 10/12 Kinesis and was printed and bound
by Courier Companies, Inc., Stoughton, MA. The cover was printed by
Phoenix Color Corp.

 © 2002 by Pearson Education, Inc.
Upper Saddle River, New Jersey 07458

Printed in the United States of America
10 9 8 7 6 5 4 3 2 1

ISBN 0-13-028070-4

Pearson Education LTD., London
Pearson Education Australia PTY, Limited, Sydney
Pearson Education Singapore, Pte. LTD.
Pearson Education North Asia LTD., Hong Kong
Pearson Education Canada LTD., Toronto
Pearson Educación de Mexico, S. A. de C. V.
Pearson Education–Japan, Tokyo
Pearson Education Malaysia, Pte. LTD.
Pearson Education, Upper Saddle River, New Jersey

CON·tents

Section V **Design Profession**

PREF·
ace

This books comes as a result of years of working in, teaching in, and writing about the field of design and art. It was triggered, in part, by a desire to reach out to those standing on the sidelines contemplating a career in design; to those uncertain about their own design abilities, or, more importantly, their design *capabilities*. It is meant to encourage others to become designers.

Considering design as a career is a big decision fraught with uncertainty. "Is this really for me?" "Am I that creative?" There is a lot of impressive design out there. Looking at it can intimidate the undecided. "I can't possibly do that." "I'm not good enough." All accomplished designers started in this same place. They faced the same uncertainty. They created designs that would make them cringe today. That, however, did not cause them to remain on the sidelines and seek another career path. Why not? What gave them the confidence to think they would succeed as designers?

Designers are creative, visual problem solvers, whether designing advertisements, brochures, video graphics, web sites, three-dimensional products, or skyscrapers. Just as some people speak with their hands, designers think with their fingers. They are always doodling or scribbling on paper, always converting what they think or see into a visual form. This is impossible to stop; it is the way they process information and develop solutions. It is not wasting time; it is satisfying a need; it is how they function.

For many students contemplating design as a career, acknowledging that need is what keeps pulling them back to design. What they create now is not exceptional or publishable, but it is visual, and it is satisfying. Like a diamond in the rough waiting to be cut, polished, and put out for display, the ability needs to be nurtured, honed, and disciplined. It will take several years of study and hundreds of completed projects for it to mature. The experience will be both satisfying and at times frustrating. The end result, however, will prove worth the journey and the future design solutions a testament to the right path taken. ✍

Susan G. Wheeler
Gary S. Wheeler

INTRO⊙·
duction

*B*eing a visual designer is fun and challenging. In every city and in every part of the country, designers are needed to advertise products, announce services, and communicate a variety of information to others. Using clever brochures, colorful posters, exciting web sites, and amazing videos, a designer's work captures people's attention and delivers a message. It speaks to people, tells them something they did not know, and presents it in a unique manner.

When considering visual design as a career, students wonder: What is the work like? What skills are needed? What is it like to design something? Is it hard? Will the years of study lead to a satisfying career? These are typical questions for anyone considering which professional path to follow. This text answers those questions through a summary snapshot of the visual design field—from its history, to the type of work designers do, to how to get that very first job.

Since the early 1980s the terms used to describe this career choice have changed along with its tools. Before 1980 the term *graphic designer* described a designer of two-dimensional, print-media graphics. Examples included publications (magazines, books), brochures, billboards, advertisements, trademarks, logotypes, packages, labels, and product graphics. In other words, anything printed and displayed on a surface. With the advent of computers, digital technology, and the Internet, a new way of executing this work became available. In addition, new applications of designers' talents, such as web-page design and web advertisements, opened new sources of design employment. The term *digital designer* emerged as a way to denote this new specialization. Other names such as *communication designer* hoped to span both areas and show their common purpose without identifying specific tools or media. In this text the term *visual designer* is used to include all uses of a designer's skill for both print media and digital display. The skills needed for both are the same, even if some of the tools vary.

A visual designer sees and harnesses the relationship between elements, such as type, visuals, and color. The designer unifies the elements so they speak with a single, focused voice to a viewer. The opposite of design is visual

chaos. Design is like a chorus that sings, harmonizes, and delivers a well-developed musical message. Visual chaos is a jumble of unrelated images on a page, as if each choir member were singing a different song.

The design principles and techniques used for focused communication are universal no matter the media—print or display, and they are paramount for successful communication. Knowing how to use the software, for example, is not enough if knowledge of design is weak or absent. A designer does not just manipulate existing elements. Through design relationships are established and the designer's perspective is imparted. A designer is a master of visual organization but also an artist, illustrator, typographer, colorist, creator, and visionary. A designer controls, recreates, and masters the elements of the design for the success of the whole. This is not a quiet, sleepy profession. Designers are passionate about what they do, because each design contains a piece of themselves, their vision, open to scrutiny.

A visual designer is a visual problem solver. The designer assumes responsibility for someone else's problem, such as a client's need to promote a product or service. Companies selling automobiles, cleaning products, sports equipment, beauty products, or entertainment services need to notify potential customers of their products' benefits, qualities, and availability. Companies offering services, such as child care, animal health care, gymnastics lessons, transportation, tutoring, or equipment repair (the list is endless) want customers to know their capabilities and value. These diverse companies need visual designers to communicate their messages effectively to potential customers.

The relationship between a designer and a client is one of mutual need. Unlike fine artists who explore visual problems of their own creation, a designer explores someone else's visual problem with a specific goal in mind—increased sales or exposure. The challenge and excitement come from the diversity of problems to solve and the inherent conundrum of being creative within limitations. Rather than exploring the nuances of a visual problem through a series of twelve paintings executed over the course of a year, as a painter might do, the designer can

jump from a web page to an advertisement to a billboard for as many different clients during the course of a single week.

Being a designer is exciting. Some days the solutions to client problems come fast and furious, making the designer feel brilliant and gifted. Other days inspired solutions feel out of reach. Every designer has good and bad days as well as favorite solutions or those solutions best forgotten.

Choosing a career involves selecting a type of work most suited to the personality, talents, and interests of an individual. The test of success is whether, over the course of several months, rather than within a single day or week, the work brings enjoyable challenges and intellectual growth.

The Visual Design Primer *is intended* to whet the appetite for a more detailed study of the design field. It provides an introduction to the subject with a brief sampling of design history, design personnel, professional tools, design components, design applications for specific problems, and finally a brief summary of procedures for entering the profession. Whether the individual expects to work in a bustling metropolis or a quiet rural town, the need of businesses to communicate with their customers is universal. There is no one correct place to practice this profession or one unique way to execute its work. A few practitioners receive life-time achievement awards, but most have the satisfaction of an enjoyable, challenging career providing intellectual and professional growth with continued excitement and satisfaction. Both are meritorious as a measure of a lifelong career. ✼

BACK·ground

The term *graphic design* was coined by William Addison Dwiggins, the noted typographer and designer, in 1922 to describe "his activities as an individual who brought structural order and visual form to printed communications...." Today's visual designer executes the same activities, with the addition of all digitally displayed communications. Deciding to pursue a career in visual design requires information and consideration. What are the job responsibilities? What tools are used? Who is involved? What is the field's history? What is meant by professionalism in the design field? Where can this career path lead? With these questions satisfactorily answered, the preparations necessary to enter the field are exciting and the reward is the successful achievement of becoming a visual designer.

CHAPTER 1

HIS·*toric*
MILESTONES

*T*he evolutionary chronology of a field can follow many guideposts—stylistic, cultural, or technological. Many factors influenced the evolution of graphic design, none more fundamentally than its technology. When Gutenberg invented the means to reproduce legible, readable book text using reusable metal type, the door to mass communication started to swing open. With today's immediate, worldwide distribution of information over the Internet, designers continue to seek new ways to communicate information and to challenge limitations.

Nicolas Jenson (c. 1420–80)
French type cutter & printer

Aldus Manutius (1450–1515)
Venetian printer & typographer

C. Garamond (c. 1490–1567)
French type founder & designer

William Caslon I (1692–1766)
English type founder & designer

John Baskerville (1706–75)
English printer & typographer

William Morris (1834–96)
English designer & printer

Jules Chéret (1836–1932)
French poster artist

Eugène Grasset (1841–1917)
Swiss book & poster designer

Howard Pyle (1853–1911)
American illustrator

Toulouse-Lautrec (1864–1901)
French poster designer, painter, & printmaker

105 A.D. **Paper** invented in China by Ts'ai Lun.

A.D. 868 **Relief printing** used by Chinese to print first book.

1045 Movable type made from clay first developed in China by Pi Sheng.

Metal type 1403 cast from bronze used for book printing in Korea. Not widely used due to number of characters in language.

1454 Gutenberg invented the first practical, movable, reusable type. Adapted his letterpress printing press from wine and cheesemaking presses.

1570–1700 Illustrations reproduced as copperplate engravings.

1796 Senefelder invented lithography, the printing of visual images from flat limestones. It became a widely accepted method for reproducing illustrations.

Papermaking machine 1803 first operated in England to produce large quantities of paper economically.

1810 König patented the steam-powered cylinder printing press. It was twice as fast as the existing hand-operated printing presses.

2

1822 Niepce invented sun engraving, an early photogravure technique for making metal intaglio printing plates from drawings on paper.

Niepce created **1826** the first photograph from actual objects by exposing the image all day onto a pewter sheet.

1837 Engelmann patented the *chromolithographie* process in France, for printing full-color illustrations from stones.

Palmer **1841** opened the first advertising agency in Philadelphia.

1846 Hoe invented the rotary lithography press in America. It was six times faster than the flat-bed presses of the day.

Bulluck **1856** developed the first web press in America.

1860–1900 Chromolithography was a color lithographic process that used from five to twenty color impressions for a single print. This technique dominated illustrative printing during this period.

Moss invented a **1871** photoengraving process for making engraved metal plates from line art. It replaced the expensive, hand-cut, wood engraved plates.

1875 Barclay patented the offset lithography process in England, for the printing of tin packaging material.

Muybridge was the first **1877** to use sequence photography. His concept served as the basis for motion-picture photography.

1880–1890 Photomechanical reproduction of photographic printing plates replaced hand platemaking techniques and dramatically reduced production costs and time.

Frederic Goudy (1865-1947)
American type designer & founder

Edward Penfield (1866-1925)
American poster artist

C. R. Mackintosh (1868-1928)
Scottish designer & architect

Peter Behrens (1868-1940)
German designer & architect

Will Bradley (1868-1962)
American graphic designer

Aubrey Beardsley (1872-98)
English illustrator

Ludwig Hohlwein (1874-1949)
German poster artist

Eric Gill (1882-1940)
English type designer & artist

Hans Rudi Erdt (1883-1918)
German poster artist

Lucian Bernhard (1883-1972)
German poster & type designer

Piet Zwart (1885-1977)
Dutch typographer & designer

Stanley Morison (1889-1967)
English typographer & scholar

Lazar El Lissitzky (1890-1941)
Russian graphic designer

E. M. Kauffer (1890-1954)
American graphic designer

Beatrice Warde (1900-69)
American type historian

Herbert Bayer (1900-85)
Austrian graphic designer

A. M. Cassandre (1901-68)
Russian poster designer

Jan Tschichold (1902-74)
German typographer

Lester Beall (1903-69)
American graphic designer

Ashley Havinden (1903-73)
British graphic designer

Cipe Pineles (1910-91)
Austrian graphic designer

B. Thompson (1911-95)
American graphic designer

H. Tomaszewski (1914-)
Polish poster designer

Paul Rand (1914-96)
American graphic designer

Yusaku Kamekura (1915-)
Japanese graphic designer

Armando Testa (1917-92)
Italian graphic designer

Herb Lubalin (1918-1981)
American graphic designer

Lou Dorfsman (1918-)
American graphic designer

1881 **Ives** developed a process to create halftones that later was refined with the Levy brothers into a reliable commercial technique.

Mergenthaler 1884 invented the Linotype linecaster typesetting machine that mechanized typesetting and increased the printing of newspapers, periodicals, and books.

1889 **Lithographic press** was introduced. It printed directly from zinc plates rather than stones.

Rotogravure invented in England, **1894** a photomechanical intaglio rotary printing process.

1897 **Pyle** created a full-color illustration that was printed with the new four-color process system.

Offset lithography press 1906 developed by Ira Rubel in New Jersey. The press enabled printing to a variety of textured paper surfaces.

1925 **Phototypography** introduced in London as a commercially viable typesetting option.

Rondthaler 1936 introduced phototypography in the United States.

1960 **Phototypography** replaced foundry type as predominant typesetting method due to increased typesetting speed and lower production costs.

Pantone Matching System 1963 provided designers and printers with a system of numbered colors that enabled color accuracy in all stages of design development and production.

1970 **International Typeface Corporation** founded to encourage typeface development and provide licensing protection for typeface designs.

1984 **Apple Macintosh computers** initiated the digitization of professional art creation and production. They merged the designer's access to tools and capabilities onto a single computer through multiple software applications.

PostScript computer language 1984 described the contents of the digital graphic page, including type, color, bézier graphics, and high-resolution bitmapped images. This language introduced desktop publishing capabilities to a wide variety of professionals.

1984 **PostScript Digital typefaces** offered designers access to professional-quality digital typography on their computers. Moved typesetting responsibilities to designers.

Laser Printer introduced. **1985**

1990 **Digital typography** replaced phototypography as major typesetting method in the design industry due to its easy access on the computer.

World Wide Web 1990 is the interactive linking of Internet computers throughout the world. It was initiated by scientists in Switzerland for scientific information sharing.

Technological constructs are only part of what propels this industry's development and success. A designer's creativity and ability for synthesizing and organizing disarate written and visual information into a comprehensible whole gives this technology its purpose. A designer applies visual design fundamentals, typographic principles, color theory concepts, and knowledge of past and present design movements to successfully communicate the message to the viewer. Technology is the vehicle that facilitates the delivery and expedites the creation of their designs; mastery of it enables designers to explore exciting new visual ideas and images. ℘

Saul Bass (1921-96)
American graphic designer

Muriel Cooper (1925-)
American graphic designer

Wim Crouwel (1928-)
Dutch graphic designer

Jan Mlodozeniec (1929-)
Polish illustrator & poster artist

Milton Glaser (1929-)
American graphic designer

R. O. Blechman (1930-)
American illustrator & animator

Seymour Chwast (1931-)
American graphic designer

Tom Geismar (1931-)
American graphic designer

Shigeo Fukuda (1932-)
Japanese graphic designer

Ivan Chermayeff (1932-)
British graphic designer

Heinz Edelmann (1934-)
German graphic designer

Gert Dumbar (1940-)
Dutch graphic designer

April Greiman (1948-)
American graphic designer

Javier Mariscal (1950-)
Spanish graphic designer

TAR·get AUDIENCE

*V*isual design is all about influencing and persuading. A good design persuades the viewer (the intended audience or target audience) to pick up the document, to read the headline and text, and to buy the product or subscribe to the service. Who should this design influence? is one of the first questions the designer asks because it determines the overall design approach taken, the typefaces selected, the colors chosen, the visual images used, and even the size of the typefaces used. All visual design decisions address the known preferences of the target audience in order to have greater impact.

Who should this design influence?

The **design** of a package for software can use all sorts of digital, high-tech images, with wild futuristic graphics and "techno" typefaces. However, what if the software is intended to teach girls ages five through nine about caring for pets? What if it is an adventure game for boys ages twelve through sixteen? What if it is software for adults interested in online investing? The design approach for the packaging changes for each group or target audience. Why?

Male?
Female?
Homemaker?
Executive?
Adult?
Child?

What is a target audience?

Selected group of people with a common trait or interest

A *target audience* is any selected group of people with common interests, attributes, or traits. These traits can be based on age, gender, geographic location, shared hobbies, health issues, educational interests, and many other factors. A narrowly defined target audience will have a similar response to advertisements, packaging, web pages, or presentations due to their shared traits. How can the designer understand this group well enough to create something that appeals to them when he or she does not share those same attributes? The designer gets to know them. He thinks about what makes them who they are. She observes and talks to them or, professionally, reads a demographics study prepared by a market analyst.

Which features to emphasize?

Use?
Quality?
Taste?
Effectiveness?

An interesting exercise for designers is the following: Think of someone you know well who is quite different from you in terms of tastes in food, clothing, or type of interests. This might be a friend, relative, co-worker, or neighbor, just someone you know well. Think of a product this person purchased and uses frequently that you do not use. Many things about that product appealed to the purchaser. It fit into a lifestyle, solved a problem, tasted good, or appealed to a sense of values—so much so that this person bought it. Identifying these shared values or needs within a target audience and appealing to them through the design solution is key to a successful design—a design that sells the product.

What appeals to them?

Colors?
Illustrations?
Design Styles?
Type?
Photos?

Visual designers solve wide-ranging visual communication problems for others—individuals and companies who need to communicate to a specific audience using print or display media. The challenge for beginning designers is to get beyond their own personal likes and dislikes and put themselves in the place of the intended purchasers—the target audience. Seeing the product or advertisement through their eyes improves the effectiveness of the design and the likelihood of its purchase or eventual adoption. ℘

DE·sign PROCESS

*D*esign as a profession is a collaborative, synergistic endeavor—a sequential process with many participants. The design process for print media is a chain of events beginning with a client's need for a brochure or advertisement—a piece of visual persuasion—and ending with a printed solution satisfying that need.

The final design solution is influenced by myriad factors and art professionals from the initial design phase, when the work of other artists influence the design, to the production phase, when prepress technicians and printers require properly prepared files for **trapping**, platemaking, and printing. Just like a relay team, where each member has a specialized task intended to assure victory, the design process has a team of skilled designers and printers affecting its successful conclusion. The project travels a circuitous track starting and finishing with the client.

When the client needs a persuasive promotional brochure to describe a product and enumerate its features and benefits to potential customers, the designer is the first point of contact. The client explains the need, the product, its target audience, the budget limitations, and the required deadline. The designer's responsibility is creating several markedly diverse visual solutions in the form of layouts for the client's review and approval. The creative process is influenced by the work of other designers and employs techniques that trigger new ways to graphically present information (see chapter 8). The completed layouts, usually three, are presented to the client during a formal presentation where the designer explains the reasons for the design choices and their applicability to the client's needs.

Once a final design solution is approved by the client, the designer converts the selected **layout** or **comprehensive** into finished artwork as required by the printer, the next professional along the track. At this point, paper distributors and printers are consulted to ensure glitch-free finished art. Each printer with whom a designer works has an experience-honed procedure for prepress work (trapping, color separation, and plate preparation) and presswork (ink selection, press proofing, finishing, and binding) ensuring error-free printing that meets the deadline. Precisely adhering to the printer's requirements assures a successful outcome and keeps costs low.

Just as all members of a relay team execute specific tasks during the race, their correct preparation for the handoff to the next runner is critical for a team victory. Smooth handoffs to all the other graphic art professionals along the design-process track ensures the same success. ✍

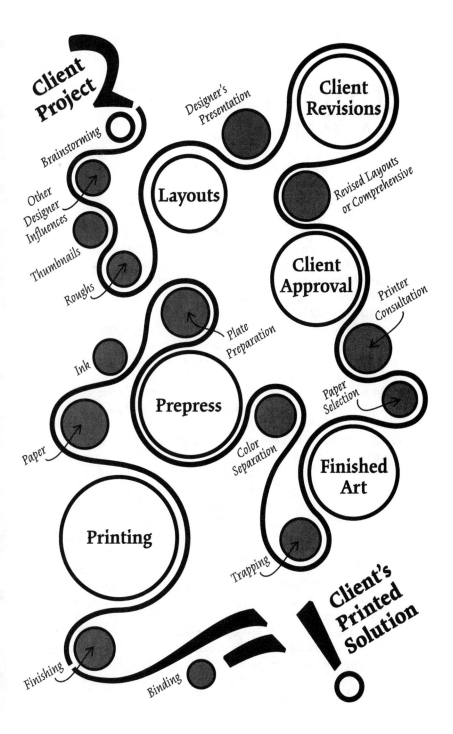

CHAPTER 4

PRO*fes·* SIONALISM

*T*o do something professionally means to make a living at it over a significant period of time, to receive payment for work that is enjoyable and satisfying. Companies or individuals hire professionals to provide services they cannot accomplish themselves. It might be out of their area of expertise, or they might not have the time to do it. However, professionalism goes beyond earning money. Professionalism describes the conduct, manner, and expertise exhibited while completing the task.

In the design field, for example, a company that sells and distributes health-care products might hire a designer to create a brochure promoting their merchandise. A professional designer understands what developmental steps this project will undergo from initial meeting to printed brochure. Designers know about type, design, marketing, and color, but they also know about preparing finished camera-ready artwork, prepress techniques, paper, and printing processes. Designers do not execute each and every step personally, but they know who can complete the steps they do not. A professional knows how to take responsibility for a company's problem, to solve it, and to provide an effective brochure ready for distribution. Any problems that arise during the process are the professional's to solve to the client's advantage.

What causes a company to hire one designer over another besides the content of the portfolios? Professionalism. A professional designer establishes an atmosphere of trust, convincing the client that the project is in qualified hands. This is done by explaining the *what* and the *why* of design, presenting a professional appearance, using the design language, and expressing detailed knowledge of the field. Unlike a fine artist whose artwork explores personally defined visual problems over a flexible time period, professional designers are artists-for-hire who solve visual problems for others within a preset deadline. To get the job, they must convince others they can get the job done satisfactorily.

A successful design solution is a lopsided compromise between what the client wants and what the designer wants. Explaining layouts (proposed solutions to visual problems) to clients requires an articulate designer who understands design principles and can explain their validity to a possibly nervous client who may find the design world unfamiliar and intimidating. This understanding of design, its uses and applications, and the ability to explain it demonstrate a professionalism, a mastery of the field, and identify a designer as one with the ability to get the job done—on time, within budget, and to the client's benefit. ✍

Design
PRE·liminaries

In 1972 Milton Glaser, eminent graphic designer and illustrator, summarized the function of a designer: "The best work emerges from the observation of phenomena that exist independently of each other. What the designer intuits is the linkage,... He sees a way to unify separate occurrences and create a gestalt, an experience in which this new unity provides a new insight.... That's what design is about...."

A designer approaches design with two sets of skills. The skill of a craftsman requires a facility with tools and drawing skills. The skill of a designer requires an understanding of the client's visual problem, research, a knowledge of the creative process, and the ability to trigger, channel, and recognize creativity. Laying the correct foundation for design determines the success of the path to it.

CHAPTER 5

TOOLs

In 1984 the introduction of the Apple Macintosh computer and Adobe's **PostScript** computer language and digital typefaces initiated the complete digitalization of the professional art field's tools and technologies. Previously used tools, such as French curves, circle templates, acetate, rubylith, and transfer type, gradually gave way to computers, digitizing tablets, graphics software, digital typography, scanners, and digital cameras.

Creativity Tools

Freehand mark-making tools and image-capturing tools used to initiate ideas and create thumbnails, layouts, and illustrations.

Pencils & Markers

Opaque, transparent, and graphite mark makers for thumbnails, layouts, comprehensives, or photo indication.

Drafting Tape

Triangle
Slide side-to-side along T square.

T square
Grasp head; slide up or down along edge of drafting table.

Knife
Cut along a straight edge.

Illustration Board
Plate- or vellum-finish bristol board laminated to thick cardboard for executing finished art and illustrations.

Technical Pen
Hold vertically to create single-thickness ink line.

Rubber Cement & Thinner
Use thinner to determine adhesive's tack.

Pigmented Media
Transparent or opaque medium for expressive color or monochromatic illustrations.

Paper
Translucent and opaque thin, white papers used for layouts, tracings, marker renderings, and thumbnails.

The principles, theories, and concepts behind art creation have not been altered, nor has the need for artists to impose their will and vision on the images they create. What have changed are the tools and techniques for art production, presentation, and distribution. Moreover, the designer's responsibilities in those areas have increased.

Digitizing Tablets

Tablet and pressure-sensitive stylus that creates freehand, expressive lines like a pencil or marker.

Computer Operating Systems

Systems that distinguish computer platforms. An **operating system** (os) determines how the software interacts with the hardware and provides the appearance and functionality of the screen before the specific software is opened. Operating systems include the Mac os, Windows, dos, and Linux.

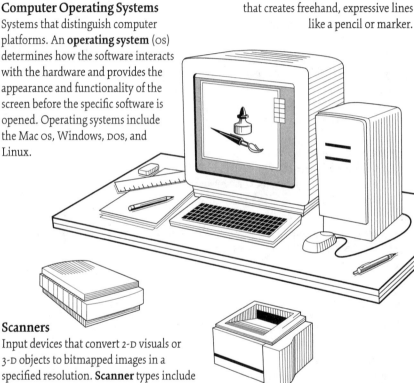

Scanners

Input devices that convert 2-D visuals or 3-D objects to bitmapped images in a specified resolution. **Scanner** types include flatbed, handheld, 3-D, and ocr.

Printers & Plotters

Color and black-and-white output devices. Printing **resolution** ranges from 72 dpi to 2400+ dpi. Paper sizes range from 8½" × 11" to large formats measured in feet. Printer types include laser, ink jet, impact, and dye sublimation.

Cameras

Image-capture devices that shoot to film or **digitize** images at a specified resolution and save them to disk, memory cards, or **RAM**.

Production Tools

Precision and creative instruments, hardware, and software that transform client-approved layouts into reproducible images, such as **line art**, digital art, reflective art, or camera-ready finished art. These tools convert the one-of-a-kind layout or comprehensive (comp) into the appropriate form and quality for distribution.

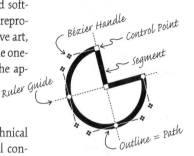

Vector Graphics Software

Precision line- and shape-creation software for technical drawings and finished art. Employs mathematical concepts to create curves and straight lines (paths) using control points and segments. A path is a single object with a stroke (outline) and a fill (color or texture). Objects are altered by manipulating **bézier** handles and control points. Line clarity is dependent upon output-device resolution.

Object-oriented (vector) software defines a graphic as an object with an outline, fill, on-screen position, and size.

Bitmapped Graphics Software

Continuous-tone image creation software for illustrations. Replicates traditional art tool effects, such as paint brush, airbrush, conté crayon, and charcoal. Stores images as picture elements (pixels) within a grid (bitmap). Images are altered by editing the pixels on the bitmap. Image clarity is dependent upon software resolution and output-device resolution.

Raster (bitmapped) software defines an image as a two-dimensional pixel mosaic plotted on a grid or bitmap.

Pixel (picture element) is the smallest unit of bitmapped image.

Page-Layout Software

Vector software for reproduction-quality finished art. Manipulates all page elements (graphics, type, color). Graphics are scaled, rotated, and reflected. Type is set with precisely calibrated type controls. Assigns color as **spot color** systems and **process colors** and outputs as separations. Implements production controls for **register marks**, **crop marks**, **bleeds**, color separations, and trapping. This software is used for advertisements, **newsletters**, and brochures.

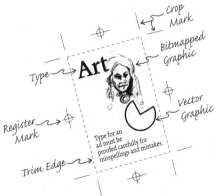

Original Drawing

Edited Drawing

Digital Editing Software

Bitmapped graphics capabilities used to manipulate, edit, and alter scanned or captured images, such as drawings or photographs. Capabilities include color enhancement, image removal and replacement, or image collaging. Graphic style effects, such as mezzotint, mosaic, embossing, stained glass, and many others are available to alter images. Image clarity is dependent upon resolution of scan, software, and output devices.

Typeface Classifications
- Humanist
- Old Style
- Transitional
- Modern
- Slab Serif
- Sans Serif
- Script
- Decorative

Presentation Software

Vector or Internet-browser software for projected page-display sequences during meetings or presentations. Imports and manipulates page elements, such as type, color, and graphics. Capabilities include color selection, text entry, visual element transformation (rotate, reflect, scale), movement across screen, audio effects, video sequencing, attribute controls, and color selection.

NATIVE AMERICAN JEWELRY
- HAIDA
- HOPI
- NAVAJO
- ZUNI

Web Site Software

Bitmapped software for the creation and display of web pages and sites. Manipulates text, graphics, and color and incorporates special effects, such as audio, video, and animation. Also structures hot links between pages for nonlinear or linear movement throughout site.

Web Site Hierarchy

As with other revolutions where dramatic technological advancements took place, a blending of techniques has occurred to link established methods with the new. Scanning technology bridged the gulf between traditional and digital technology. Designers learned to use hardware and software for art production but maintained reliable preexisting techniques for thumbnail, layout, and illustration creation. By keeping what worked along with accepting the improvements, designers increased the quantity and quality of their output. ✍

CHAPTER 6

CREA·*tive* PROCESS

Creating something, whether a poem, research paper, three-dimensional sculpture, musical score, or two-dimensional design is the end product of a process, a series of steps called the *creative process*. Some, mistakenly, believe creativity is an act of spontaneous enlightenment, an inspirational jolt. Professional designers know that it is the result of a procedure that provides them with the necessary information to produce a creative visual interpretation of their client's information.

Receive Design **1** Problem

- *Understand problem & ask questions*
- *Intended target audience?*
- *Project goals?*

Research Problem **2**

- *Collect data from multiple sources*
- *Review designs for similar products*
- *Research suitable design styles, illustration styles, & typographic treatments*

Creativity is a skill to nurture, not inspiration to receive.

It takes practice, practice, practice to keep it working properly.

Gutenburg's invention did not occur on a specific day in 1454, but was rather a culmination of events (research, thought, abundant preliminary sketches, failed working models, and repeated refinements) that resulted in a functional version of his initial concept. The creative process is the successful culmination of a sequence of preparatory steps that produce unique visual ideas for print or display media, thoughtful prose and poetry, or history-altering inventions.

Organize **3** Research Data

- *Review project goals to set priorities*
- *Prioritize facts & features*
- *Select design styles, illustration styles, & typographic ideas*

Create **4** Thumb nails

- Serves as quick, visual brainstorming
- Take design risks!
- Don't judge
- Experiment!

When a beginning designer "gets stuck," it is usually due to a lack of adequate preparation. This is analogous to trying to drink from an empty cup. When a design problem is researched properly with written and visual information in abundance, the result is too many credible ideas from which to choose, not too few.

TIP

When interrupted during the creative process, write a note describing the intended next step.

Work resumes easily with these mind-refocusing notes.

Render **5** Layouts

- Execute as tight marker on layout bond
- Recreate best, most diverse thumbnails at actual size

Critique **&6** Revise

- Combine successful sections of several layouts
- Keep what works & improve what doesn't
- Solves client's problem?
- Appeals to target audience?

TIP

Unique stands alone. It does not conform.

Dare to try.

Complete Final **7** Design

- Tightly execute best designs
- Watch craftsmanship & proof
- Mount or present carefully

Experienced designers refine the creative process to fit their own strengths and personal characteristics. None of them, however, tries to design something without suitable input of product information, visual design influences from other designers, vast numbers of preliminary layouts, and careful consideration of the client's goals for the project. Following the creative process to a successful end is the result of many preliminary steps that provide the designer with the fuel for generating interesting, unique, creative ideas. ✍

RE·
search

Researching a project is an important stage in a design's development. It provides the knowledge and the facts about the product or service being advertised, the range of visual possibilities for it, and the credible ideas regarding design, illustration, and typographic style a designer might apply to it. These categories of information provide the foundation for a strong, unique visual design. Without the research stage, the designer lacks the resources from which creativity grows. ༄

When?

When does a designer do research?

- *Immediately after receiving the client's project*
- *Always. Updating and maintaining a designer's morgue is an ongoing process. A morgue is one of the best resources designers have because they know what is in it and how it is organized.*

Where?

Where can a designer find current information? *In magazines, web sites, and newspapers.* Where are the most extensive visual examples located? *In design books, morgue, and art journals.* Where is the most detailed product information found? *In product videos and manufacturer or user interviews.*

- **Art Journals/Magazines**
 - *Communication Arts*
 - *Graphis · Print*
- **Magazines**
 - *Product-Related*
- **Design Books**
 - *Specific Design Areas*
- **Web Sites**
 - *Competitors'*
 - *Related Products'*
- **Designer's Morgue**

- **Newspapers**
- **Product Videos**
- **Illustrated Dictionary**
- **Interviews**
 - *Manufacturer · User*

- **Technique Influences**
 - *Illustration Style*
 - *Design Style*
 - *Typography Style*

How?

How does the designer know what information is important?
How does the designer organize it?

- **Answer Questions**
 1. *Who makes it? Company?*
 2. *Where is it? Location?*
 3. *What is it? Product?*
 4. *What does it do? Function?*
 5. *Important characteristics?*
 6. *Target audience attributes?*

- **Write or Draw List**
 - *Images representing questions 2 through 5*
 - *Related visual styles*
 - *Related visual techniques*

- **Prioritize Information**
 - *Organize list from most to least important*

How To Create A Designer's Morgue

A designer's **morgue** is a collection of pictures torn from magazines, newspapers, and catalogues organized by categories in an easily accessible file. A beginning designer's morgue fits nicely in an accordion file. The organized, properly maintained morgue enables a designer to find the necessary reference quickly when a deadline approaches. The following suggested categories serves as a starting framework.

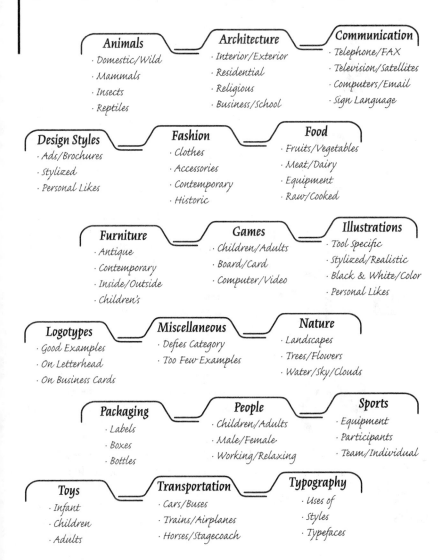

Animals
· Domestic/Wild
· Mammals
· Insects
· Reptiles

Architecture
· Interior/Exterior
· Residential
· Religious
· Business/School

Communication
· Telephone/FAX
· Television/Satellites
· Computers/Email
· Sign Language

Design Styles
· Ads/Brochures
· Stylized
· Personal Likes

Fashion
· Clothes
· Accessories
· Contemporary
· Historic

Food
· Fruits/Vegetables
· Meat/Dairy
· Equipment
· Raw/Cooked

Furniture
· Antique
· Contemporary
· Inside/Outside
· Children's

Games
· Children/Adults
· Board/Card
· Computer/Video

Illustrations
· Tool Specific
· Stylized/Realistic
· Black & White/Color
· Personal Likes

Logotypes
· Good Examples
· On Letterhead
· On Business Cards

Miscellaneous
· Defies Category
· Too Few Examples

Nature
· Landscapes
· Trees/Flowers
· Water/Sky/Clouds

Packaging
· Labels
· Boxes
· Bottles

People
· Children/Adults
· Male/Female
· Working/Relaxing

Sports
· Equipment
· Participants
· Team/Individual

Toys
· Infant
· Children
· Adults

Transportation
· Cars/Buses
· Trains/Airplanes
· Horses/Stagecoach

Typography
· Uses of
· Styles
· Typefaces

CHAPTER 8

SEE·ing DESIGN

Faucet Face

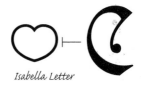

Isabella Letter

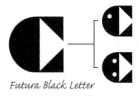

Futura Black Letter

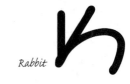

Rabbit

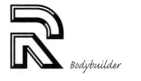

Bodybuilder

First and foremost, designers must be able to recognize good design, before creating it themselves. They must be able to see design possibilities in unlikely places or to take the trite and make it new. Everyone can *look* at something and examine what is present, what is visible. Designers *see* past the obvious to the possible and present it for others to experience. Children gaze at the sky and see a dragon, rather than a puffy cumulus cloud, or look in the sink while washing and see a face. What enables one person to see beyond the obvious to the unexpected?

Design Principles at Work

The capital letter *C* from the Isabella typeface looks like the left half of a heart. The same letter from the Futura Black typeface looks like a fish (profile) or a crab (bird's-eye view). Why does each of two images designed to be the same letter suggest something else? In each case, it is the letter's *proportions* (distribution of visual weight) that are reminiscent of another familiar image.

The Isabella *C* has a large negative shape on top and tapers to a positive-shape point on the bottom just like a traditional heart shape. The Futura Black *C* has a large positive shape on the left balanced by two smaller shapes on the right. In a real fish or crab the same proportion exists between the body and fins or the body and claws.

Focal point (where the eye enters the image), or emphasis, is another factor for a visual association with another image. The capital letter *K* from the Farfel typeface looks like a rabbit. The two large ears on the left capture the viewer's attention first. Once the head is established, the body quickly falls into place.

A final factor is perhaps the most important. The designer's mind must be willing to accept these unexpected visual associations and not be constrained by realism. Once that restriction is eliminated, the visual possibilities are endless. The capital letter *R* from the Newtron typeface, for example, can be seen as a stylized, posed figure of a bodybuilder. The figure is seen from the front, with the head bent forward, legs apart, and the left arm arced to the side in a flexed position. If this letter *R* can be a bodybuilder, anything is possible. Designers see these possibilities and bring them to the attention of others.

• Cat's nose and mouth • Martini glass • Stethoscope • Person doing handstand • Bird (profile)	• Sitting cat (back view) • Drum major (front) • Person driving (profile) • Person reading book • Human embryo	• Two adjacent houses • Covered bridge • Mountains • Pig's snout • Church
• Tadpole • Robin catching worm • Monocle • Snake after swallowing large mouse	• Cat's head • Frog with open mouth • Laughing mouth • Car emerging from tunnel	• Bird • Human face • Hammer • Outdoor water pump • Hatchet
• Smiling face • Sad skier • Penguin with large feet • Wilting flower in pot • Person reading book	• Baby bird in nest • Figure running • Metronome • Car stick shift (profile) • Compass	• A-frame house • Primitive stick trap • Lean-to shelter • Open book with spine up • Pup tent

- Brainstorming
- Visual Manipulation
- Graphic Formatting

Problem: Design symbol to identify organically grown wheat. Symbol will appear on wheat bags and organic wheat product packages.

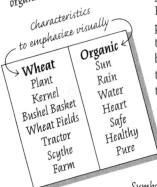

Characteristics to emphasize visually

Wheat	Organic
Plant	Sun
Kernel	Rain
Bushel Basket	Water
Wheat Fields	Heart
Tractor	Safe
Scythe	Healthy
Farm	Pure

Symbol Layouts

Creativity Triggers

Once new designers master seeing design possibilities in preexisting situations, they are ready for the second stage—manipulating the environment to create original designs currently seen only in *their* mind's eye. There are several techniques that help trigger this kind of creativity from the freewheeling to the focused.

Brainstorming

Brainstorming is the freewheeling approach to creativity. It is an "idea dump"—good and bad, terrific and terrible. Every idea is welcome. The designer writes a list of *all* the possible images or ideas associated with the problem. Brainstorming is free of judgment; quantity is most important. Dividing the list into several major characteristics to emphasize in the visual focuses the process. The best brainstorming method is one that keeps up with all the ideas that are flowing fast and furious and that records them for later consideration.

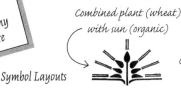

Combined plant (wheat) with sun (organic)

Combined plant (wheat) with heart (organic)

Car Manipulation Thumbnails

Front View

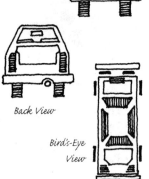

Back View

Bird's-Eye View

Visual Manipulation

Visual manipulation is a second creativity-triggering technique, in which the designer views the subject from a unique vantage point. View it from above (a bird's-eye view), from below, from the front, or from behind. Manipulating the object by magnifying, stretching, flattening, bending, combining two images into one (see organic wheat symbol above), or twisting creates unique design possibilities. New ideas are triggered just by seeing an ordinary object from an unusual perspective.

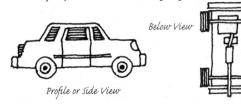

Below View

Profile or Side View

Graphic Formatting

Graphic formatting is the third creativity-triggering technique that depicts visual analogies between seemingly unrelated actions or objects. It provides a visual structure for text and images, so that they appear logically arranged or organized. Using this technique, a designer could employ a familiar graphic image, such as a pulley, to visually explain the concept of teamwork. A graphic based on the structure of an atom could provide a unique way to organize a table of contents in a genetics book. Design is organization. Using preexisting graphic structures helps the designer organize complex or daunting information for better viewer understanding.

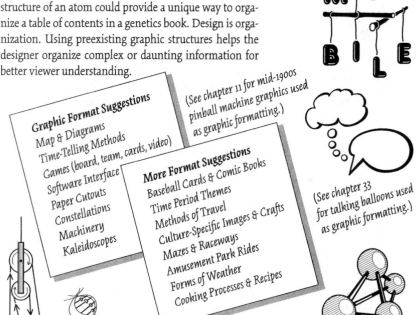

Graphic Format Suggestions
Map & Diagrams
Time-Telling Methods
Games (board, team, cards, video)
Software Interface
Paper Cutouts
Constellations
Machinery
Kaleidoscopes

More Format Suggestions
Baseball Cards & Comic Books
Time Period Themes
Methods of Travel
Culture-Specific Images & Crafts
Mazes & Raceways
Amusement Park Rides
Forms of Weather
Cooking Processes & Recipes

(See chapter 11 for mid-1900s pinball machine graphics used as graphic formatting.)

(See chapter 33 for talking balloons used as graphic formatting.)

Designers enjoy exploring design possibilities. It is the what-if-we-did-this stage of design development. This is the time to take risks, explore preposterous notions, and try outrageous ideas. All designers, even the famous ones, have ideas that do not work. A good designer recognizes them as such and keeps on going. They do not doubt their abilities or debate whether to go into a new line of work—they just try again!

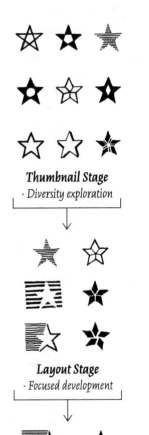

CHAPTER 9

thumbnails
LAYOUTS
& COMPS

Thumbnail Stage
· *Diversity exploration*

Layout Stage
· *Focused development*

Comp Stage
· *Detail resolution*

*T*humbnails, layouts, and comprehensives are all forms of visual presentation used by a designer and client at different stages of an idea's development. Each form employs different tools that produce a unique visual style indicative of the idea's completion level and the client's level of involvement.

Design Development Stages

The first stage, the **thumbnail**, is seen only by the designer. A *thumbnail* is a visual record of the designer's thought processes executed in a personal graphic shorthand. Thumbnails are fast, freewheeling, and not subject to extended consideration—quick, passing thoughts.

To execute a thumbnail on a computer with its precise lines and accurate shapes would require much more of the designer's time than this stage warrants. Its pristine form indicates a greater commitment to the idea than may exist. The end product is no longer indicative of a passing thought, but rather a definitive, well-considered idea.

The second stage of a design's development is the layout. A *layout* is an actual-size sketch, usually executed in markers, colored pencils, and/or ink, that presents a more accurate appearance of the proposed advertisement, brochure, or design. A layout is used for obtaining client input or redirection before finalizing the design. Once again time and commitment are indicated by the layout's visual form. The rough quality of marker and colored pencil lines indicates an idea in progress. The client will feel comfortable discussing it and making suggestions.

The third stage of design development is the comprehensive or comp. A *comprehensive* represents the closest visual form to the actual printed piece. This stage has benefited from the designer's freewheeling thoughts and the client's input, and it is usually subject to minor changes, if any. It is an opportunity for the client to check final color choices and design and copy corrections from the previous stage before authorizing the design's production.

A developing design is a work in progress that evolves in accordance with the designer's creativity and the client's approval. Executing a design in a form appropriate to its developmental stage keeps its progress moving quickly and effectively to the benefit of the design.

Thumbnails

A thumbnail is a rough sketch of an initial design idea for the designer's review. It contains all the visual elements—headline, text, illustration or graphic, and company identification. The purpose of a thumbnail is to enable the designer to work out the overall design structure of the visual quickly without getting bogged down in the details. A thumbnail is imperfect, a preliminary draft. Detailed design modifications are made at the next stage of development.

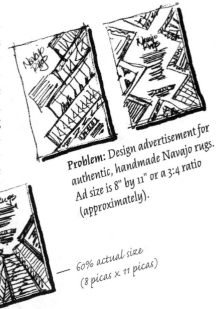

Problem: Design advertisement for authentic, handmade Navajo rugs. Ad size is 8" by 11" or a 3:4 ratio (approximately).

Headline

Text

Graphic

Company Identification

— 60% actual size (8 picas x 11 picas)

· Use correct proportions.
· Execute in pencil on layout bond.
· Do not evaluate—produce!
· Combine successful sections.
· Keep all thumbnails for later review.
· Select the best three and proceed to layouts.

Correct proportions are paramount to creating a useful thumbnail. A tall, thin advertisement requires a tall, thin thumbnail with the same proportional relationship between the width and height. The size relationship between the internal components must be accurate also. Ignoring these proportions is counterproductive. It is comparable to designing a square peg for a round hole. Design for the space the client stipulated.

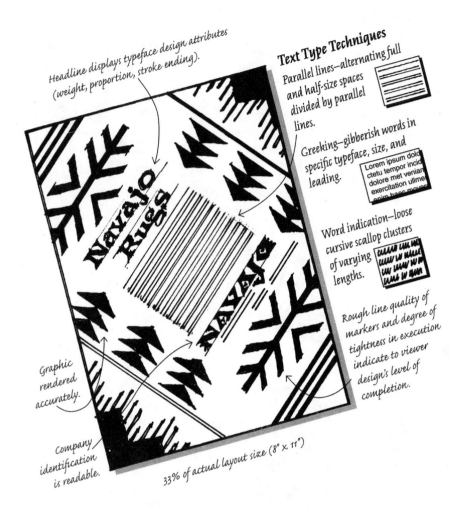

Headline displays typeface design attributes (weight, proportion, stroke ending).

Text Type Techniques

Parallel lines—alternating full and half-size spaces divided by parallel lines.

Greeking—gibberish words in specific typeface, size, and leading.

Lorem ipsum dolo ctetu tempor incid dolore met veniar exercitation ullme enim haec movey

Word indication—loose cursive scallop clusters of varying lengths.

Rough line quality of markers and degree of tightness in execution indicate to viewer design's level of completion.

Graphic rendered accurately.

Company identification is readable.

33% of actual layout size (8" × 11")

Mounting Specs

Equal Distance Top and Sides

Layout on Layout Bond

White Poster Board

Larger Distance on Bottom

Layouts

A layout is a tight, full-size sketch of a design idea. It is an essential design development step for both the designer and the client. The purpose of a layout is twofold. First, it enables the designer to refine or alter the design details from the thumbnail stage, where size, speed, and stage of development do not warrant such careful scrutiny. Second, the layout provides the client with several, usually three, diverse design solutions to review, revise, redirect, or select for creation as comp or finished art.

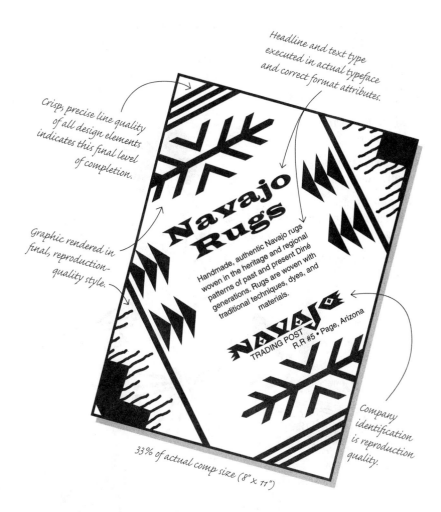

Headline and text type executed in actual typeface and correct format attributes.

Crisp, precise line quality of all design elements indicates this final level of completion.

Graphic rendered in final, reproduction-quality style.

Navajo Rugs

Handmade, authentic Navajo rugs woven in the heritage and regional patterns of past and present Diné generations. Rugs are woven with traditional techniques, dyes, and materials.

NAVAJO TRADING POST R.R #5 • Page, Arizona

Company identification is reproduction quality.

33% of actual comp size (8" x 11")

Comprehensives

A comprehensive is the closest representation of the finished, reproducible design. Many times the comp is created from the actual finished artwork. Not all designs go to this stage. If a client has been working with a designer for a long time and the designer has done this kind of project for the client previously, a comp may be unnecessary. If the client is new or it is a particularly complex project, the comp provides the last step, or safety net, before the client authorizes its printing. 🐾

> Package comps are photographed for ads, brochures, and web pages before the actual printed package is available.

WORK·sheet

THUMBNAIL· LAYOUT·COMP

- Think and explore options; do not judge.

- Use familiar, easily controlled tools.

- Keep all design iterations; combine successful sections of several.

- Use abundant research materials.

Thumbnail Stage

Development of the butterfly image begins as many quick ideas executed in pencil on tracing paper and marker on layout bond.

Generate as many as possible.

Thumbnails stress variety.

An ordinary thumbnail can evolve into a unique layout.

Layout Stage

Development continues as focused revisions of
three select thumbnails and produces layouts for
client viewing and input.

*Pencil on tracing paper is a fast way to
explore variations while maintaining
all work for later review.*

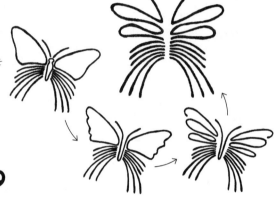

*Present three distinctly different
layouts for client review.*

Comprehensive Stage

Last design iteration for final client approval resolves details
such as angles, line endings, line weights, and shape
refinement.

*Client may request to see one or more
layouts as comprehensives.*

Incorporate client changes from layouts.

*Execute on computer;
use file later for
finished art.*

DRAW·ing

Designers enable viewers to visually experience common themes and images in unique ways. They share their own mind's-eye view of ideas, concepts, and objects through their artwork. They reintroduce others to the world around them through unusual associations or unexpected emphases. To paraphrase Milton Glaser, designers can create something unique from the visual linkages of independent phenomena.

Putting these novel linkages into a viewable form necessitates another skill—the ability to draw. When creating unique images, there are no existing references to copy. Drawing enables a designer to put his or her ideas on paper, to give them visual form. The drawing tool used, subject to personal preference, is only the mechanism with which a designer executes this task. Drawing is a skill. It translates the three-dimensional sensory input of actual, realistic form or the imaginary creation of the designer's mind into a two-dimensional visual illusion. Drawing is an ability to be honed over time, unlike a tool to be purchased in a matter of moments.

To say the ability to draw is unnecessary to a designer is to say that a poet does not need to know how to speak or write. How can designers communicate their design vision if they cannot translate the idea they imagine into an image for others to behold?

Some believe that the ideas are what make the designer. They prefer to let other craftsmen translate their ideas into visible imagery. Others rely only on preexisting images to recreate their ideas. As explained and demonstrated in the previous chapter, a design evolves. It is improved from one developmental stage to the next or from one thumbnail to the next. An intermediary craftsman might not share the designer's vision or creative abilities and could unintentionally divert, weaken, or fundamentally change the original design concept. Visuals taken from stock collections might not capture the subtleties necessary to communicate the designer's idea accurately.

While designers do not have to be accomplished illustrators with myriad styles at their command, designers must be able to translate their mind's-eye images easily and accurately to paper. Otherwise, they have a viewing audience of only one. ✍

Design
COM·*ponents*

In his 1993 book, *Design Form and Chaos,* Paul Rand, world-reknowned graphic designer, stated: "To design is much more than simply to assemble, to order, or even to edit; it is to add value and meaning, to illuminate, to simplify, to clarify ... to persuade.... Design broadens perception, magnifies experience, and enhances vision. Design is the product of feeling and awareness, of ideas that originate in the mind of the designer and culminate ... in the mind of the spectator." Designers manipulate multiple visual elements from color to type, emphasizing one and underplaying another to strike the correct balance for optimum communication and impact. Manipulating the elements improves with personal experience and professional awareness. Robert Bringhurst, typographer and author, said: "Instinct ... is largely memory in disguise. It works quite well when it is trained, and poorly otherwise."

DE·sign

Headline Large-size type used to draw viewer's attention to page or give synopsis of the story.

Visuals Photographs, graphics, illustrations, or diagrams used to enhance the headline, get viewer's attention, or provide additional information.

Text Small-size type used to explain subject of the page.

Space White or negative space that serves around the page exterior as margins, between lines of text, and around the visuals.

Company Identification Logotype or symbol used to identify company, product, or service responsible for or identified on the page.

Subhead Medium-size text used to clarify headline or divide text.

Caption Small-size text that explains and identifies visuals.

The purpose of writing a book is the desire to communicate information to the reader. The writer organizes the content (the text and visuals) to lead the reader logically through unfamiliar verbal terrain. By prioritizing the information, the writer enhances the effectiveness of the communication and eliminates reader confusion. A book's beginning is predetermined—chapter one, page one. By simply turning the page the reader follows the writer's train of thought.

Communication by Design

The purpose of designing a single page, advertisement, or web page is the need to communicate information to the viewer using text and graphics. The visual starting point is not physically predetermined, as in a book. The information is not doled out page by page, each one in turn. In contrast, a page's content is immediately available in its entirety on the same two-dimensional surface, as if all visual elements were speaking at once. In addition, a web page must be designed as a related component within the entire **web site**.

With good design, the designer establishes visual priorities for the page using the page's elements and leads the viewer logically and smoothly through the unfamiliar visual terrain. As a result, the communication stream is a coherent, unbroken thread. The viewer receives the information in the order determined by the designer. With poor design, viewers can start anywhere within the message and proceed backwards or forwards depending upon which visual element attracts their attention. As a result, the viewers' eyes bounce around randomly within the page just as a ball in a pinball machine. The message is jumbled and ineffective.

Design is synonymous with organization, with structure. Getting all the visual elements to *fit* within the confines of the page is not enough. The designer must control *when* each element is seen by applying the principles of design to the visual elements. Ultimately, a designer's goal is the same as a writer's—the successful delivery of a message. This success is not happenstance; it is design.

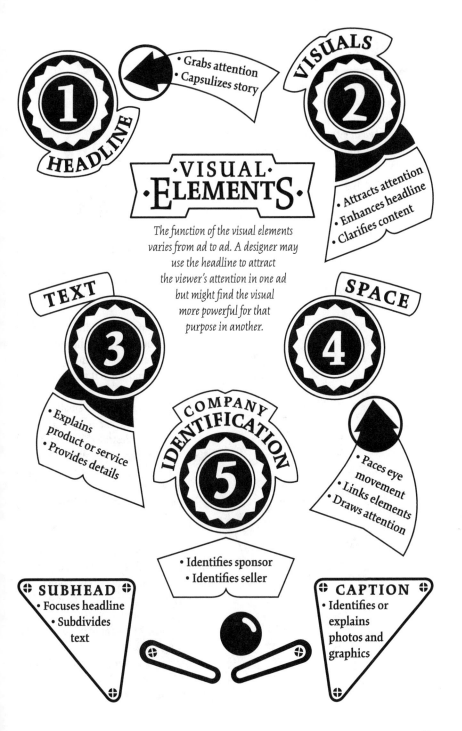

VISUAL ELEMENTS

The function of the visual elements varies from ad to ad. A designer may use the headline to attract the viewer's attention in one ad but might find the visual more powerful for that purpose in another.

1 HEADLINE
• Grabs attention
• Capsulizes story

2 VISUALS
• Attracts attention
• Enhances headline
• Clarifies content

3 TEXT
• Explains product or service
• Provides details

4 SPACE
• Paces eye movement
• Links elements
• Draws attention

5 COMPANY IDENTIFICATION
• Identifies sponsor
• Identifies seller

SUBHEAD
• Focuses headline
• Subdivides text

CAPTION
• Identifies or explains photos and graphics

❮ ELEMENT ATTRIBUTES ❯

A design is like a roadmap. A successful design takes the viewer from a point of origin along a predetermined route through all the visual elements to a final destination. In design, this route is called the *page map*. This is a visual journey for the eye. The point of origin is the first element that attracts the viewer's attention. The eye then progresses to the second attraction, then on to the third, and so forth. The journey ends when the viewer reaches the designer's destination, becomes distracted, or loses interest in the topic.

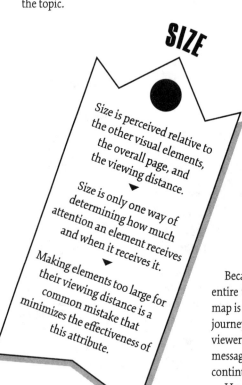

SIZE

Size is perceived relative to the other visual elements, the overall page, and the viewing distance.

▼

Size is only one way of determining how much attention an element receives and when it receives it.

▼

Making elements too large for their viewing distance is a common mistake that minimizes the effectiveness of this attribute.

COLOR

Color is perceived relative to the other visual elements, the page, and its external environment.

▼

Color contrast, intensity, and quantity affect how much attention an element receives and when it receives it.

▼

Using a tint on a small shape, such as text or a thin rule, can destroy the integrity of that shape and weaken its visual impact.

Because a viewer might not stay for the entire trip, the final destination on a page map is not the most important point of the journey; actually, it is the reverse. The viewer must comprehend the gist of the message quickly in order to be enticed into continuing.

How does a designer visually prioritize information in an ad, brochure, or web page and thereby keep the viewer engaged?

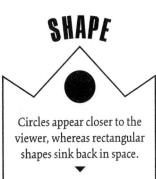

SHAPE

Circles appear closer to the viewer, whereas rectangular shapes sink back in space.

▼

Overlapping shapes create a sense of depth.

▼

Breaking the horizontal and vertical orientation of a page is visually dynamic.

▼

Text blocks are shapes that visually interact with other visual elements.

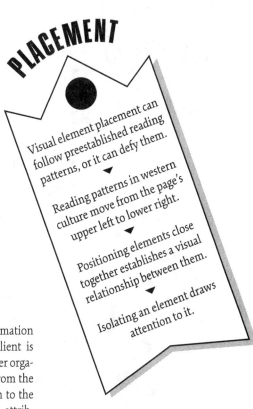

PLACEMENT

Visual element placement can follow preestablished reading patterns, or it can defy them.

▼

Reading patterns in western culture move from the page's upper left to lower right.

▼

Positioning elements close together establishes a visual relationship between them.

▼

Isolating an element draws attention to it.

Prioritize Elements

A designer visually prioritizes information by first understanding what the client is saying. Once that is clear, the designer organizes the visual message elements from the broadest, most general issues, down to the details by carefully controlling the attributes of each element.

A successful page map keeps the viewer on the page while moving from the most important element (the attention getter) to the subsequent elements in descending order of importance. The map does not set up a circumstance where the viewer is led off the page in the middle of the message or is confused as to how to proceed. Confusion will end the journey. Not all ads, brochures, or web pages will be read in their entirety. With that in mind, designers should make sure the viewer leaves the page with a general knowledge about the topic (product or service) and who offers it (manufacturer or seller). With that message delivered, the viewer can return for more information if the need arises or can inform someone else who might benefit.

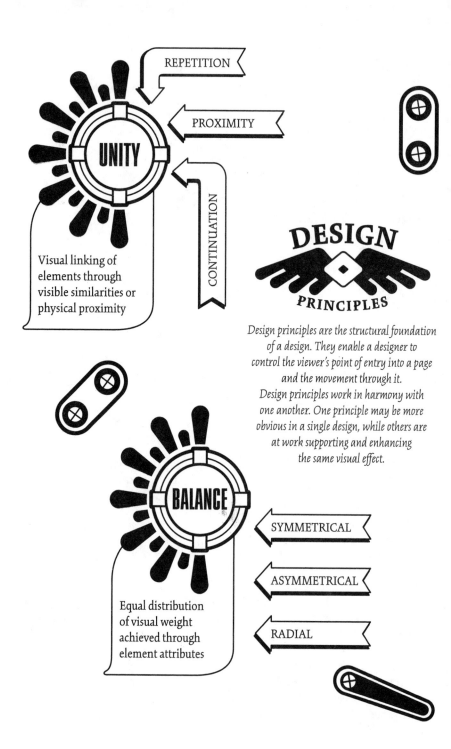

REPETITION

PROXIMITY

CONTINUATION

UNITY

Visual linking of elements through visible similarities or physical proximity

DESIGN

PRINCIPLES

Design principles are the structural foundation of a design. They enable a designer to control the viewer's point of entry into a page and the movement through it.
Design principles work in harmony with one another. One principle may be more obvious in a single design, while others are at work supporting and enhancing the same visual effect.

BALANCE

SYMMETRICAL

ASYMMETRICAL

RADIAL

Equal distribution of visual weight achieved through element attributes

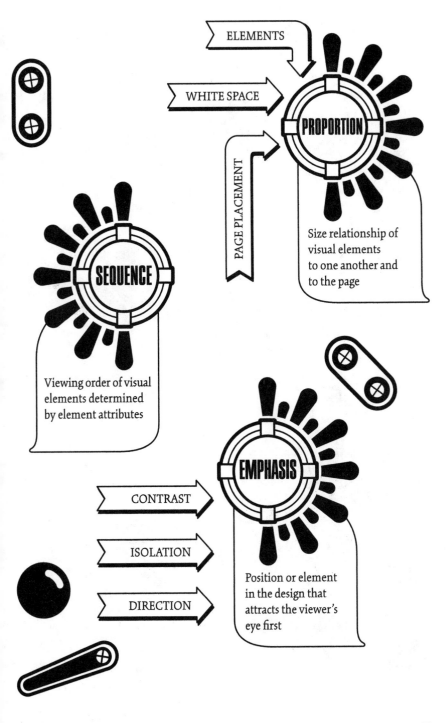

ELEMENTS

WHITE SPACE

PAGE PLACEMENT

PROPORTION

Size relationship of
visual elements
to one another and
to the page

SEQUENCE

Viewing order of visual
elements determined
by element attributes

EMPHASIS

CONTRAST

ISOLATION

DIRECTION

Position or element
in the design that
attracts the viewer's
eye first

Shape placement and repetition of triangles and circles unifies the design.

Shape proximity creates a unique whole linking previously isolated, unrelated shapes.

Viewer's eye moves ▶ through elements unifying the page.

Alignment of element edges ▶ facilitates the continuation of movement between distant shapes.

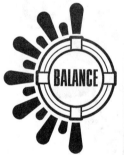

◀ Symmetrical balance suggests a horizontal, vertical, or diagonal midpoint axis within the design.

Asymmetrical balance optically equalizes shapes through their attributes. In this case, larger, simpler shapes balance multiple smaller shapes.

◀ Radial balance arranges elements in a circular pattern.

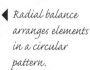

Varying size of negative (white) shapes adds another visual element and regulates speed of movement through the design. ▶

▲ Varying size of positive (black) shapes relative to one another creates a more dynamic visual.

PROPORTION

▲ Element size relative to page affects impact and accentuates negative space.

SEQUENCE

Shape sequences move the viewer along a preset path.

Color contrast creates a focal ▶ point that attracts viewer interest.

EMPHASIS

Movement through a shape ▶ sequence (circles and lines) can direct a viewer to a point of emphasis.

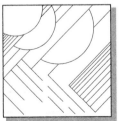

▲ Isolating shapes draws attention to them.

Design Structure

In many instances a designer is asked to design a space or page with preestablished proportions. Letter, legal, and tabloid sizes are standard paper sizes that keep paper costs reasonable and fit standard printing presses. Advertisements for magazines and newspapers, as well as billboards, come in preset variables. A web page fits the proportions of the standard computer screen. Many times the challenge for designers is how to divide a standard-size area in a unique way.

Implied +-shape

Implied ◊-shape

Implied △-shape

Implied ◁-shape

Shape Structure

A design consists of individual internal shapes (the visual elements), the external shape of the page, and the shape of all the visual elements as a collective whole. This collective shape is the framework within which the viewer's eye travels. Page structures can be based on geometric or familiar shapes, such as a cross, triangle, or S-shape. Making a page a checkerboard or dividing it evenly into quarters is uninteresting because it is too predictable. Creating a page structure that *suggests* a relationship based on a known shape, such as a distorted diamond, is familiar yet different. The noted typographer Robert Bringhurst said it best: "... structural harmony is not so much enforced as implied."

Implied □-shape

Implied S-shape

Implied ▽-shape

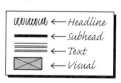

uuuuuuu ← *Headline*
━━━ ← *Subhead*
≡ ← *Text*
⊠ ← *Visual*

Implied C-shape

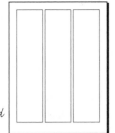

3-Column Grid

Grid Structure

When designing with multiple pages, as in a booklet, web site, or brochure, the second structural challenge is maintaining unity. Each page requires a different design due to its content, yet each page must relate to the others. A **grid**, or structural guide, is useful for long, multipage documents.

Variations Using 3-Column Grid

Variations Using Complex Grid

Complex Grid with Gutters Indicated

A page grid divides the space within the page margins into multiple, same-sized increments, or blocks. The designer determines the **proportion** and number of the blocks. How many of the blocks are used for each visual element varies from page to page and provides the necessary design flexibility as well as the underlying structural similarity that unifies all pages. 🖋

TYPE·

*T*ype is everywhere. It is in books and magazines, on web sites and in videos, on billboards and posters, and on museum displays and menus, to name a few examples. As a visual element, type contributes content (the readable message) and design context (style and mood). There is a typeface for every situation. Selecting the right typeface and **typesetting** it correctly strengthens the design's visual impact and supports the message's veracity.

Typeface *Distinctive, visually unifying design of an alphabet, its punctuation marks, and numbers.*

Type Family *All stylistic variations, such as light, medium, and bold, of a single typeface.*

Display Type *Type set 14 points or larger, used for headlines and discontinuous reading.*

Text Type *Type set below 14 points, used for paragraphs and continuous reading.*

Type Block *Shaped area of display or text type.*

Letterspacing *Horizontal space between letters in a word.*

Word Spacing *Distance between words in a line of type.*

Selecting Typefaces

To make appropriate typeface selections for a project, the designer initially asks three questions: *What? How?* and *Who?* Each answer narrows the designer's choices making a suitable selection more apparent.

What refers to content. What is the message? Is it a listing of menu entrees, a detailed explanation of investment opportunities, or the rules of a child's game? By reading the message the designer not only understands what is being said but the tone used to say it—factual? light-hearted? Type's tone influences the reader's comprehension of the message. A formal typeface projects authority and confidence about the content, like a newspaper or annual report. An informal typeface creates a casual air of familiarity with the reader, like a conversation over the backyard fence. Tone and content must match for the message to be believed.

How refers to form. How is the message delivered? Does the design use a headline, text, subheads, and captions? Is it text for continuous or discontinuous reading? By understanding the importance of form, the designer chooses appropriate display and text typefaces and typesets them correctly to facilitate communication.

A B C D E F G H I
J K L M N O P Q R
S T U V W X Y Z

A b l f y s e v v

Stroke · Ascender · Crossbar · Terminal · Eye · Mean Line · Bar · Stem · X-Height · Baseline · Counter · Serif · Spine · Descender · Roman Letter · Italic Letter

Who refers to the target audience. Who is the intended reader? Is it an on-screen reader or a print-media reader? Is it an experienced or inexperienced reader? Are there any reading-related issues associated with this audience or environment, such as poor eyesight or low resolution? By recognizing the reader and the reading environment, this last category focuses previous decisions more narrowly for the final typeface selection.

Type Selection and Function

A designer selects and sets type for both display and text purposes. Success with both determines whether the reader reads the words on the page without distraction or fatigue. Display type is used for headlines and subheads. Headlines attract attention to the articles, and subheads divide them into smaller, easily read sections. Headings are short, typeset phrases that establish a topic and require only seconds to read. Display type is text for discontinuous reading. Text type delivers the substance and details of the message. This is type for continuous reading. The reader must read the entire paragraph or page to fully comprehends its meaning.

↑ Informal (imprecise, casual, soft)

Typography
Typography
Typography
Typography
Typography
Typography
Typography
Typography
Typography

Formal (precise, crisp, rigid) ↓

Display type draws the viewer's attention to the beginning of an article or section. Choosing a typeface with unusual design features or simply a heavier weight within one type family achieves that goal. A subhead is secondary in visual priority to the headline, so its design or weight should reflect that to the viewer. Rules concerning readability and legibility that are critical for text type can be suspended for display due to its larger size and different function.

Text typeface selection emphasizes two factors: design *unity* and *legibility* (letter-shape identification). It is the designer's responsibility to facilitate the reading of the text, so the client's entire message is delivered and understood. Selecting a text typeface that achieves that goal is an important design decision.

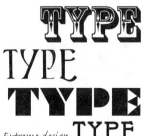

Extreme design characteristics make excellent display type.

Type *Avoid extremes for text type selection.*

D W T | Aabcd
Contrasting design

ABC | Aabc
Contrasting letter proportions

P | Aa
Similar letter proportions

F | Aa
Similar angled stroke endings

A | Aa
Similar flared stroke endings

H | Aa
Similar rounded stroke endings

The design of a text typeface must complement that of the display type while being legible (see "Type Selection and Design Unity"). Text is third in typographic priority behind headlines and subheads, but its selection must be unified with the display typeface and overall visual style of the page.

The typeface designer determines the legibility of a typeface. Typefaces designed with extreme proportions (condensed or extended), stroke weights (hairline or ultra black), and design styles (highly decorated or stylized) are not suitable for text type. These extremes challenge the reader's ability to identify the letter shapes in text's small sizes. Light- and book-weight type have better clarity of form, since the **counters** (negative shapes in and around the letters) are larger, making the shape-defining letter strokes easier to see in the smaller sizes. Page after page of paragraphs set in roman letters, for example, are easier to read than those set in italic letters due to the reader's greater familiarity with the roman letter shape.

Type Selection and Design Unity

A common mistake of beginning designers is selecting too many type families for one project. All those tantilizing typefaces are hard to ignore. This bounty of typefaces creates a ransom-note effect and replaces design unity with visual chaos. One well-chosen, extended type family provides the necessary variety while maintaining unity; two families offer unique visual diversity; three or more trigger visual chaos.

Choosing two compatible families involves contrast and similarity as applied to design features and letter proportions. Contrast is the easier of the two to implement. The designer selects one family in an attention-getting design for display and a simple, easy-to-read design family for text. With letter proportions, a display type with wide or extended letters contrasts a text family with a narrower letter width.

Similarity is the more challenging to implement and can be ignored until contrast is mastered. It emphasizes one particular design characteristic shared by both the display and text type for unity, while maintaining enough contrast to avoid visual confusion.

1. Put one space after all sentences and colons.
2. Use a typesetter's apostrophe (') and quotation marks (" ") rather than a prime (') and double prime (").
3. Use *f-i* (fi) and *f-l* (fl) ligatures.
4. Use hyphen (-) for line breaks, joined compound words, and noninclusive numbers.
5. Use en dash (–) for inclusive numbers.
6. Use em dash (—) instead of a double hyphen (--) to set off a break in thought.
7. Italicize names of periodicals and books and italicize space before them.
8. Never hyphenate or justify headlines and subheads.
9. Do not indent the first paragraph after a heading.
10. Align baselines across text columns.
11. Use no more than three consecutive line-end hyphens in a paragraph.
12. Remove widows (word smaller than four letters or last half of hyphenated word used as last line of paragraph).

Typesetting Type

Typesetting is the conversion of copy, the message's individual words, to correct typographic form for the printed or on-screen page. Correct typesetting involves two factors: typographic *form* and *readability* (word, sentence, and paragraph identification and comprehension). Typographic form is achieved through appropriate use of font characters (**ligatures**, typesetter's apostrophes, and many others) and control of type attributes (size, **leading**, line length, letter case, letterspacing, and alignment). Proper typographic form distinguishes typesetters, a role designers now play, from typists. Typesetting is an art that advanced designers perfect. Beginners should start by employing some typesetting basics and learning to use **proofreaders' marks**.

Type Size

Type size is measured in points (72 points = 1 inch). Different typefaces set in the same point size are not optically equal due to how the letter's size is distributed above and below the **baseline**. Designers should judge type size in its actual viewing environment, so the influences of proportions, type quality, and viewing distance are judged accurately. The designer's eye is the best typographic tool for this decision.

Set in caps. *caps*

Set this in Lowercase. *lc*

Set ALL in lowercase. *lc*

Insert hyphen. =/

Insert quotes. ᵛⁱ|ᵛⁱ

The type's apostrophe. ᵛ

Use this em dash. M

Use 6|8 en dashes. N

Italicize word. *ital*

Insert space. #

Use equal space. *eq* #

Use and find ligature. fi

Be fluent with ligatures. fl

Use proofreaders' marks in pairs:
one in text, one in margin.

Leading

Leading is the vertical distance between type lines measured in points from baseline to baseline. This measurement includes the type's size and the white space between the adjacent type lines. Proper leading enhances readability by isolating type lines, thereby deemphasizing distractions from dangling descenders and rising ascenders. This isolation keeps readers moving horizontally, rather than vertically, through the words. Serif typefaces require less leading because the serif helps define the line as a horizontal bar, aiding the eye's horizontal movement. Sans serif typefaces (*sans* means *without*) require more leading because the white space is the only device defining the type lines as horizontal shapes. Insufficient leading causes *line skipping* (reading the first half of one line with the second half of the next).

Type proportions also play a role in determining leading size. Designers should determine leading size using their eye and not rely on *autoleading* (mathematically determined leading calculated by software). Once again the well-trained eye is the designer's most accurate type tool.

A new paragraph is identified either with extra leading between paragraphs or an indention—not both. First-line indents are unnecessary after headlines or subheads, since the heading identifies the beginning of a new paragraph. The second, third, and subsequent paragraphs under the same heading are indented.

Line Length

A paragraph's **measure** (line length) also affects readability. Lines that are too long or too short disrupt the reader's rhythm with preventable distractions. A long line causes *doubling* (rereading the same line) because the reader has trouble finding the start of the next line. A short line constantly sends the reader back to the left edge after only a few words, so a comfortable rhythm is never established. Both situations break reader concentration. A measure should range between 60 and 75 characters in length (including punctuation and spaces) for single type columns and between 40 and 50 characters for multicolumn pages. These guidelines apply to continuous text only.

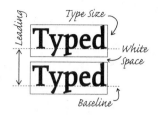

Leading is determined
by type proportions
and type size. *10/12*

*Leading too small for type
proportions = low readability.*

Leading is determined
by type proportions and
type size. *10/12*

*Leading correct for type
proportions = high readability.*

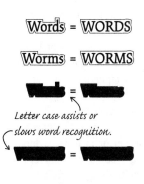

Letter case assists or
slows word recognition.

Words have
unique shapes.

Distorted
shapes

weaken
readability.

Flush Left

Centered

Flush Right

Justified

Letter Case and Spacing

Letter case decisions focus on the appropriate use of upper- and lowercase letters within a type block. Uppercase, or capital, letters are excellent attention getters. They stand tall and shout their message making them appropriate for display type. Lowercase letters are suited to continuous reading, aiding the reader with word recognition. Readers quickly move through a paragraph by identifying every word's unique shape, rather than sounding out individual syllables or identifying letters one by one. Words set in all caps lose their unique shape, forcing the reader to slow down.

Tracking (adjustment of paragraph-wide letterspacing) should remain unaltered in paragraphs. Substantially increased tracking distorts familiar word shapes, stretching them and thus diminishing readability. *Kerning* (adjustment of letter-pair spacing) is done in display type when necessary (see chapter 19).

Alignment

Paragraph alignment influences readability due to its affect on the spacing between letters and words. Too much or too little spacing distorts familiar word shapes. Flush left is the easiest alignment to comprehend because word and letterspacing stay consistent throughout the paragraphs. Justified type is also easy to read if spacing does not vary noticeably from line to line. Software provides the controls necessary to set justified type, but default settings are usually incorrect for fine typography. Both flush right and centered alignments are harder to read since the line beginnings and endings change from line to line. This alignment is appropriate for discontinuous text only.

Working with type is functional design, from the largest headline to the smallest text. It should be embraced as both a challenge and a design necessity. By ignoring these typographic design challenges, a designer leaves a significant percentage of the page unicorporated into the overall design. There are excellent books on the use of type that expand this short introductory summary. 🦋

CHAPTER 13

IDEN·
tity

Companies manufacture products or offer services to customers. This company, product, or service is a complex entity that needs a distinctive visual identification in print- and display-media materials. The visual is a *summary image*. It provides a simple visual identity, a graphic shorthand, for a more detailed concept. True corporate identity includes not only this symbol, but also all tangible forms of company paraphernalia, including advertisements, signage, uniforms, web pages, and letterheads. This chapter focuses on the symbol.

Forms of symbolic identity fall into two major categories—typographic (**logotype**) or pictorial (symbol or icon). A symbol, icon, or logotype is a summary representation. It cannot go into details. Designing such an image is comparable to describing someone in three words. The speaker prioritizes the person's characteristics and picks one word to describe each of the three most important characteristics. The same philosophy applies to designing an identifying symbol or logotype—characterize, summarize, prioritize, and stylize. ✌

Logotype *A single word or words designed to be a cohesive, readable, visual whole that usually functions as a graphic identity for a product, company, or service.*

Stylize *To design according to a visually distinct and unifying manner or technique.*

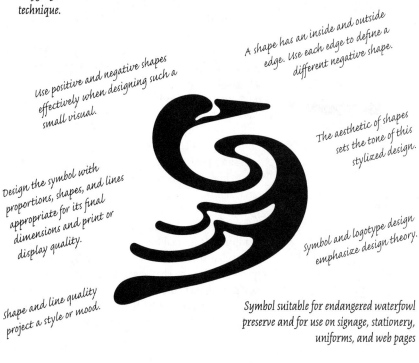

Use positive and negative shapes effectively when designing such a small visual.

A shape has an inside and outside edge. Use each edge to define a different negative shape.

The aesthetic of shapes sets the tone of this stylized design.

Design the symbol with proportions, shapes, and lines appropriate for its final dimensions and print or display quality.

Symbol and logotype design emphasize design theory.

shape and line quality project a style or mood.

Symbol suitable for endangered waterfowl preserve and for use on signage, stationery, uniforms, and web pages

COLLEGE OF *Arts* / Science

*Marker layouts of symbols and logotype
for an arts and science college*

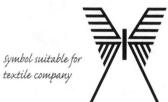

COLLEGE OF ARTS AND SCIENCE

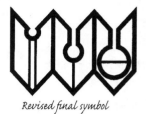

Revised final symbol

*Symbol suitable for
textile company*

*Symbol suitable for urban monorail
transportation system*

*Symbol suitable for company specializing in
solar energy production and distribution*

*Logotype based on
Navajo rug designs*

Logotype for art orientation program

Logotype based on stylized coffee bean

WORK·sheet
IDENTITY

- Design symbols in black and white.

- Design positive and negative shapes.

- Create timeless, not faddish or soon-to-be dated, images for longer use.

- Limit complexity for strong impact.

- Use heavy lines and spaces, not gradients or tints, for accurate reduction.

Thumbnail Stage
Selected thumbnail from which layout variations evolve

Layout Stage
Layout variations explore many ways to integrate bird image with water.

Emphasize bird as a whole while using lines to suggest water and bird's wing.

Layouts start with open (left side) image, then experiment with closed symbol. They return to open image and add fluid, rhythmic shapes.

Closed symbol lost shape of bird.

Layouts executed in pencil and markers on layout bond and tracing paper.

Comfortable, easy-to-use tools generate more unexpected and successful design options.

Layouts are the designer's investigation of a single design. Explore the options.

Keep all variations. This enables return to previous iteration for exploration in a different direction.

Final layout iteration to scan. Ready for comprehensive stage.

Subdivided head shape with white to balance and unify it with body.

Developed from stark, streamlined thumbnail to rhythmic, fluid, graceful symbol.

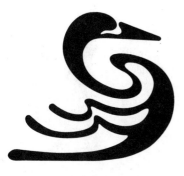

Comprehensive Stage

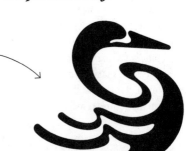

Comprehensive development focuses on refining negative and positive shapes, while repeating shapes and angles throughout symbol.

Symbol Finished Art

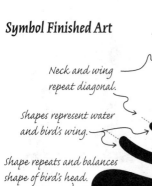

Neck and wing repeat diagonal.

Shapes represent water and bird's wing.

Shape repeats and balances shape of bird's head.

Bottom beak line repeats at bottom of symbol.

Weight of breast balances weight at back of head and end of tail.

VISU·als

Visuals for the page are created using a variety of techniques and physical structures. Visual creation techniques encompass traditional, photographic, and digital media. These techniques produce original images that grow from a blank sheet or screen to captured images that are photographed or scanned. The visuals created range from illustrations (realistic renderings), graphics (stylized representations), graphs (visual data), collages (image medleys), and photographs. Designers manipulate, reproduce, and integrate these visuals by understanding the physical structure each image needs for use in print or display media.

Original Visuals

Original traditional visuals created with traditional tool-on-paper techniques vary in complexity. A black-and-white, pen-and-ink drawing represents the simplest form of art, called *line art.* Line-art visuals are composed of solid black lines, dots, and shapes and are easy to reproduce in print or digital media due to simplicity of form and small file size, respectively.

Pen-and-Ink Drawing

Graphite-Pencil Drawing

A graphite-pencil drawing, marker rendering, colored-dye illustration, and ink-wash drawing are examples of *continuous-tone art.* Continuous-tone visuals consist of various colors and values that blend smoothly from one into another and must be converted to a different form for use in print or digital media.

Original digital visuals created with graphics software are structured as bitmapped or vector graphics (see chapter 5). The style of the visual determines the choice of software. A hard-edged graphic is easier to execute as a vector graphic. A softer-edged image with a freehand or painterly appearance excels in the bitmapped environment.

Vector Graphic

Bitmapped Graphic

Creating both line and continuous-tone digital art is possible by controlling the document's **bit level**. *Bit level* refers to the amount of color information used to describe a single pixel. Line art is the equivalent of the computer's 1-bit environment. Each pixel displays and prints as black or white. Continuous-tone art (monochromatic or full color) is possible in the multibit (8-, 16-, 24-, and 32-bit) environment. Each pixel is able to generate a preset number of colors for its bit level. The higher the bit level, the more colors displayed, and the larger the file size.

1-Bit Line Art *Multibit Color or Grayscale*

The quality of line and shape edges in digital line art is determined by its resolution. *Resolution* refers to the number of pixels (display) or dots (printer) within a prescribed area, such as the computer's screen or the printer's print area. A high resolution means more, smaller, pixels or dots within an area. Smaller pixels create smoother edges for curves and diagonals.

For bitmapped graphics, resolution is set within the software. The ability to print or display it accurately depends upon the output-device resolution; it should be the same as or higher than that of the software. In vector graphics, the display or printed resolution is determined by the output-device resolution only; software does not control resolution.

High Resolution

Low Resolution

Digital Formats

Understanding digital formats is important in order to preserve all document information accurately when saving digital art. Digital formats save the instructions necessary to print and display the document correctly. Depending upon the software, this information can include the keystrokes for text, text formatting, graphics structure, and colors. Choosing the wrong format removes some information from the document and changes the art's appearance.

There are two types of document formats: *proprietary* and *industry-standard*. Proprietary formats are those designed for specific software and usually can be opened only by that software. Industry-standard formats are more complete (and larger) than proprietary formats and can be opened or used by a wider variety of software.

Industry-Standard Formats
- EPS
- TIFF
- JPEG
- IMG
- PICT
- BMP
- GIF

Captured Visuals

Capturing visuals, whether with a 35mm camera, digital camera, or scanner, provides the designer with access to preexisting 2-D or 3-D images and objects. Scanners, for example, make traditional art, along with its vast array of artistic styles, accessible in the digital-art environment. Cameras convert objects or products to continuous-tone images for use on web pages and in print brochures.

A black-and-white or color 35mm photograph is a continuous-tone image and takes the form of a print when developed on photographic paper or the form of a *transparency* when developed as a slide. Transparencies range from slide to print size and produce more accurate color for print media than photographic prints.

Digital-image capturing using digital cameras or scanners (flatbed or 3-D) provides the designer with an immediate computer-ready image to manipulate or place in a document. Digitizing plots an image onto a bitmap (grid). Each bitmap unit, pixel or dot, is the same size, determined by its resolution. Its color is described according to its bit level. *Digitizing* means to describe something numerically. A digitized image is divided into bitmap units whose location, size, and color are described numerically.

*Bitmap Unit
(Pixel or Dot)*

X,Y coordinates identify bitmap unit location.

Bitmap

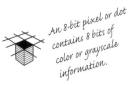

A 24-bit pixel or dot contains 24 bits of color or grayscale information.

An 8-bit pixel or dot contains 8 bits of color or grayscale information.

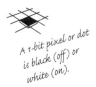

A 1-bit pixel or dot is black (off) or white (on).

How a digitized image is output to display or print media determines how it should be digitized. Image quality, file size, output-image dimensions, and color quality are important considerations when digitizing for both media. Capturing unnecessary information, such as scanning an entire photo when only a cropped portion will be used or scanning 24-bit color for an 8-bit display, creates needlessly large, cumbersome files. These files consume excess amounts of disk space, display or print slowly, and do not improve output image quality. ✐

Bit Level Color Production
1-bit = black/white
8-bit = 256 colors/grays
16-bit = 32,768 colors/grays
24-bit = 16.8 million colors/grays

Display-Media Digitizing Basics

Resolution Output resolution for display is measured in pixels per inch (ppi). Display resolution is low, typically 72 ppi. Set digitizing resolution to 72 or 75.

Image size Scan image or save digital photo in actual output dimensions to keep file size small and display time fast.

Bit level Typical display levels are 8- to 16-bit. Higher levels slow display time without noticeably improving image quality.

Line Art Scan as 8-bit grayscale at 72-ppi in actual output size.

Grayscale Art Same as line art.

Color Art or Object Create as 16-bit color at 72-ppi in actual output size. Use 8-bit if image size is too large.

Print-Media Digitizing Basics

Resolution Output resolution for print is measured in dots per inch (dpi) and ranges on average from 300-dpi to 2400-dpi. Digitizing resolution varies according to image type. Continuous-tone art is converted to a halftone before printing (see chapter 15). Scan resolution is determined by halftone screen.

Image size Scan image or save digital photo in actual output size, whenever possible. Scan image larger, if size is uncertain, to keep file size small and printing time fast.

Bit level Bit level varies according to image type and output quality.

Line Art Scan as 1-bit image as close to output resolution as possible (higher resolution captures more details). Reducing (in multiples of output resolution) scanned line art increases its optical resolution. A 600-dpi image reduced by 50% becomes a 1200-dpi optical image when printed.

Continuous-Tone Art Create as 8-bit grayscale for monochromatic art or 8- to 24-bit color for color art (based on output quality). Color files are 3 times larger than grayscale files. Set scan resolution at 1.5 times output halftone lpi screen.

150 lpi × 1.5 = 225 dpi scan resolution

WORK·sheet
V I S U A L

- Apply a unique design style to a common image to create a unique visual interpretation.

- Keep a reference file, or morgue, of design styles for immediate access.

Original pen-and-ink line art drawing of knight chess piece from which the following visual variations evolve.

Based on sample illustration style found in magazine

Inspired by geometric-style pictograms

Based on medieval-style illustration sample found in book

Based on woodcut illustration

Inspired by the calligraphic typeface, Palette

Based on the design style of the typeface, Party

Based on sample
illustration style
seen on a poster

Designed as a
geometric
abstraction

Designed using
a similar family
of shapes

Based on the
abstraction of
two-dimensional planes

Inspired by Tlingit,
American Indian
artwork

■ Scaling Visuals

Reproduction size is
indicated as a percentage
of the original size (100%).

$$\frac{Reproduction\ Size}{Original\ Size} = Percentage\ of\ Original$$

Inspired by the typeface,
Commercial Script

1½" 50%

3" 100%

6" 200%

COL·*or*

Hue *Common, general name*
that denotes a broad
category of color, such as
blue, green, and yellow.

Intensity *Term used to describe*
a color's brightness or purity.

Value *Term used to describe a*
color's relative appearance of
darkness or lightness.

*W*hen working with color a designer is concerned with three things: *color selection, color application,* and *color accuracy.* A viewer's response to color is influenced by the viewing environment, by cultural conditioning, and by his or her own emotions. From a designer's perspective, working with color is governed by how color is perceived by the viewer's eye and how it is printed on the page or displayed on the computer screen.

Color provides an environment within which the viewer receives the message of the design. By correctly controlling the color of the visual elements, the designer can emphasize the prioritized message created by the design. Color supports (or defeats) the design of the page. Design principles apply to the application of color also. Balancing color on the page, using it for emphasis, creating repetition—all these affect how the reader transverses the page map.

Color Properties

Color has several properties the designer can manipulate to improve visual impact and viewer response. A **hue** is a general color-category name. On the color wheel, these hues, called *color primaries*, are arranged according to light on a visual spectrum. The colors located opposite one another on the wheel are called **complementary colors.** Mixed complements turn neutral, muddy, or brown. Side-by-side complements amplify or intensify one another on the page. A high-intensity color comes forward in space and appears closer to the viewer; it gets attention. A low-intensity color does the opposite.

Color Wheel *Diagram of the*
color spectrum depicting
relationships between
individual colors.

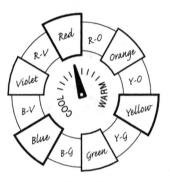

Color Wheel

Color also suggests temperature, hot and cold. On the color wheel, red and yellow are warm colors. They suggest the sun, heat, and comfort. Blue and green are cool colors. They suggest cold, ice, and cool grass. Color temperature is relative. Comparing blue and green, blue is colder. Comparing green and red, green is colder. Color temperatures should support the feeling of the message to improve viewer understanding.

The Perception of Color

Color is perceived by the viewer in two forms of light, as a *colored transmission* or a *surface reflection*. Each form, or *color model*, creates colors differently. Because designers work with both color models during a single project, understanding how each works enables the designer to manipulate color successfully and to reproduce it accurately.

Transmitted art refers to a visual whose attributes, such as shape and color, are created by projected light. A visual displayed on a computer or video screen is an example of transmitted art. The viewer sees the visual when light is transmitted to the eye in the form of glowing, colored pixels. This is the **additive color model**.

The additive color model (RGB) creates colors by combining percentages of transmitted red, green, and blue light. By combining, or *adding*, these three transmitted colors together in varying amounts, a unique palette, or *color set*, is created.

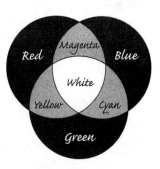

Additive Color Model

Reflective art refers to visuals executed on or printed to a surface, such as paper. The viewer sees the colored visual when light reflects off the surface back to the viewer's eyes. This is the **subtractive color model**.

The subtractive color model (CMYK) uses percentages of cyan, magenta, yellow, and black pigments to create a unique color set. An image's color is actually contained in the light that reflects off the color's surface. When white light (the presence of all colors) hits the pigment, certain colors are absorbed, or *subtracted*, from it. The colors remaining in the light are what the viewer sees. The true subtractive color model primaries are CMY, but black is added for color clarity and depth. Mixing the three original primaries actually produces a muddy brown, rather than a true black.

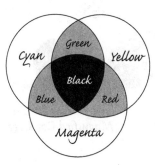

Subtractive Color Model

To evaluate color accuracy for a project's final form—the printed page or the visual display—a designer must see the colors in their correct color model and form (reflected or transmitted light). For example, the effectiveness of color selection for the printed page (CMYK) cannot be made on the screen (RGB). Even when software provides CMYK color manipulation controls, the visual display is only a transmitted-art simulation of reflective art.

The Illusion of Color

Solid Color

Designers for print media have a unique relationship with color. For some projects, color use is restricted to one, two, or three colors depending upon the client's budget. A full-color job (no limitations) is actually an optical illusion created by four colors. Optical illusions abound with print-media color.

Tint

A *spot color* refers to the printing of one ink color—full strength, right from the can. A spot color shape is an area of 100 percent solid color. To create a **tint**, or **value**, of that same spot color, the color shape is divided into lines of same-sized dots that are equidistant

Gradient

from one another when measured from their center. Each dot is still the full-strength spot color. However, since the tint shape is not solid color, the eye optically mixes each colored dot with the white of the paper surrounding it and sees a lighter value. Since all the dots are uniform in size and distance from one another, the result is a uniform value—no modulation.

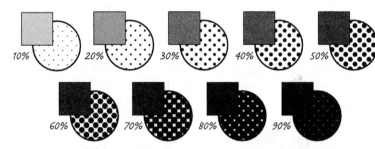

10% 20% 30% 40% 50%

60% 70% 80% 90%

To create a *gradient*, or modulated spot color, the color shape is divided into lines of variable-sized dots that are equidistant from one another (measured from center). Each dot is still the full-strength spot color, but since the amount of color (dot size) changes along with the amount of white paper surrounding it, the value changes within the single color shape.

This same technique is used when printing a black-and-white photograph. To reproduce the continuous value changes within the photograph, the photo is converted to a **halftone** (lines of variable-sized dots, equidistant when measured from the center). The clarity of the image depends upon the number of dot lines per inch (lpi). As with resolution, the more dot lines per inch (the higher an image's lpi), the less noticeable the dots and the finer the image.

Tint Scale with Magnified Dot Screens

Halftone dot enlargement from 85 lpi

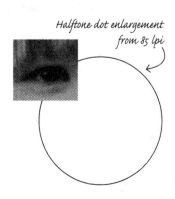

As previously discussed, each color model creates a unique color set, or palette of colors from which to choose. Spot colors come in sets also, called *color systems*. There are several industry-standard color systems: Pantone, Trumatch, and Focoltone, to name a few. Each system creates an extensive palette of colors from a small collection of primaries. A printer stocks the primaries and then mixes all the system's spot colors by combining company-specified amounts of the primaries. The development of color systems, first done by Pantone in 1963, produced a more accurate way of specifying color between designer, client, and printer. Designers always select spot colors for printing from a company-supplied print sample. Choosing print media colors using on-screen color swatches is an unreliable practice.

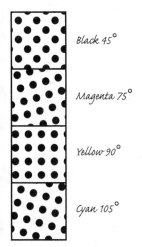

Black 45°

Magenta 75°

Yellow 90°

Cyan 105°

Process Color Print Angles

Rosette pattern enlargement shows distinct whirls of the process-color halftones.

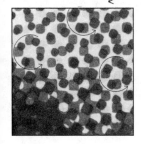

Process Colors

A full-color print-media project is actually reproduced from four colors, called *process colors*. The process colors are cyan, magenta, yellow, and black (CMYK)—black is represented by the letter K for *key*. To reproduce reflective art, such as color photographs, and line art, such as colored type, all color areas are converted to halftones or percentages of CMYK, respectively.

Magnifying a full-color magazine ad shows the way halftones and tints are used to simulate full color. A colored photograph uses four overprinted halftones of CMYK. Each color halftone is printed at a prescribed angle so the colors optically mix and balance correctly, preventing any one of the process colors from dominating. A correctly printed halftone produces a *rosette pattern*, small circular pattern of overlapping variable-sized CMYK dots, that is visible when magnified. An incorrectly printed halftone produces a *moiré pattern*. A piece of line art, such as a colored headline, is printed as overprinted CMYK tints. The number of process colors needed for each piece of line art depends on the color selected. These tints are also printed at prescribed angles for balance and optical mixing. ❧

Moiré patterns occur when the print angles of tints or halftones are incorrect or when a screened image is rescreened, as can occur when a printed halftone is scanned.

PROOF·
ing

The final step before a project goes to the client for presentation or to the printer for reproduction is proofing. Successful proofing assures everything is correct according to the client's specifications, the printer's requirements, and the designer's standards. A printed brochure or an online web page with an obvious error, such as a misspelled headline, reflects poorly on the client and turns away prospective customers. (If the company's representatives cannot spell, the viewer might doubt that the gizmo actually works.) A slow-loading web page or one with broken links discourages potential buyers. Time pressures and familiarity with a project work against the designer when proofing. Finding errors is challenging, but not impossible, if the designer uses the software and human-ware wisely.

Software provides many built-in proofing tools. After entering text, the spellchecker quickly and easily finds the misspelled word *fiind* and fixes it. Graphics programs can list a file's PMS colors, so the designer can identify inaccurate or excessive spot colors. A list of all the file's RGB and CMYK objects highlights color incompatabilities. Graphic resolution and halftone lines per inch are checked this way also. Page-layout programs list all the file's typefaces and graphics as well as the document's size and number of colors. If the file is going to a service bureau or printer, the designer makes sure that all type, graphics, and document files are sent.

Software can proof a file quickly for certain mistakes and can pull together lists of items to review, but it falls short of commonsense human-ware capabilities. After the software check is complete, the designer steps in for the rest. Are all the visual elements present—even the client's logotype? Were the client's last-minute revisions included? Last, but definitely not least, is the text error free? This means no spelling errors, no typos, no extra spaces, no eliminated sentences, no reordered paragraphs, and no embarrassing errors that even the client overlooked (double check any alteration to the client's copy with the client).

A checklist is the proofer's best friend. It reminds the beleaguered, bleary-eyed designer what to review, saving both the client and designer embarrassment, customers, time, and money. ✍

Design
PRO·duction

Design enhances the communication of information from a source to a recipient. Dissemination of information uses myriad modes, such as brochures, posters, pictograms, display presentations, and web pages. Most use type; others are pictorial. The designer's manipulation of the visual elements varies in each design mode. The initial steps, however, are the same—ask questions.

What is the purpose of this communication? Who is the intended audience? What is the viewing environment? How should the information be prioritized? Armed with the answers to these questions the designer begins to mold the information into potent communication through effective design.

PICTO⊙· *grams*

- *Use bold positive and negative shapes.*

- *Eliminate unnecessary details.*

- *Use consistent design style in a series.*

*P*ictograms function as an effective means to communicate a pictorial message to a multilingual audience, in a space too small for type, or as a unique heading. **Pictograms** and icons are used more and more in today's global environment. This picture language is widely understood. In airports, train stations, or on highways, pictograms quickly deliver a message to a fast-moving, distant, and diverse audience. On copiers, computers, and electronic devices, a pictogram delivers a complex message (e.g., press this button to do this task) in a small amount of space, at close range, and to varied users. In print and display media, pictograms are used as section identifiers for lengthy documents, web sites, and digital presentations.

A shared design style unifies these symbols into a single language and identifies their purpose to the viewer, even when not viewed simultaneously. Switching design styles for the pictograms in an international airport, for example, is comparable to writing the baggage claim sign in Spanish and the customs checkpoint sign in French. Effective communication, whether verbal or visual, benefits from consistency.

Choir Pictogram Design Series
- Purpose of communication?
 Identify source of choir concert information
- Intended audience?
 General concert-going audience
- Viewing environment?
 Hand-held or web-browsing viewing distance
- How to prioritize information?
 Broadly identify musical event as vocal, not instrumental

Designers create pictograms using bold, simple, positive and negative shapes suitable at any viewing distance. Negative shapes contribute essential subject information; they are not just "background." Effective pictograms are viewed and understood at a glance. They are focused, informative communications that make their point quickly and do not overuse details. Thin lines and unnecessary details cause confusion through clutter and are ineffective at a distance or in a small space.

Outlines disappear in distance.

Outlines do not define shapes clearly; not visually powerful.

Style Comparison

Rounded corners pull pictogram closer to viewer.

Negative shape suggests front panel of robe.

Black isolates pictogram from surrounding visuals.

Too many lines and small shapes make it difficult to read.

Design Revisions

Simplified arms and music stand by eliminating buttons and lines and bolding lines and reshaping music stand.

Eliminated connecting bar in choir. Repeated circles suggest choir as a group.

Geometric-shape pictogram for dog-walking area.

Black-on-white image appears smaller than the reverse. Its total impact is weakened.

Linear pictogram for identifying bike path.

White-on-black image has stronger visual impact.

Yield-sign shape identifies student study area and the need for quiet.

Pictograms are commonly used as a series, or **system** (see chapter 18), of images on a product, within a store, or in a public facility. The designer applies the same design style to all the visuals in the series, so they appear as a unit and their purpose is recognized with every graphic seen. Pictograms are a stylized, visual shorthand, not realistic renderings. To communicate quickly, they rely on easily identifiable images, a common visual knowledge. ✍

WORK·sheet
PICTOGRAM

- Repeat shapes and angles to facilitate movement through design.

- Simplify flow through shapes.

- Eliminate areas of visual congestion.

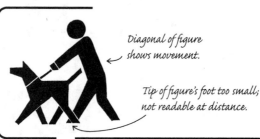

Diagonal of figure shows movement.

Tip of figure's foot too small; not readable at distance.

Layout Stage
Variations investigate subtle design issues of repeated angles and shape positions.

Eliminated hand shape.

Moved figure forward to increase size of foot.

Visually congested; draws too much attention to area.

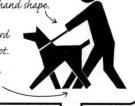

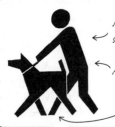

Moved figure closer to dog so they share the same leg.

Angle of figure now crowds dog.

Leg area simplified smoothing flow through shapes.

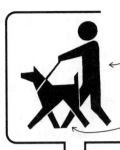

Straightened figure to eliminate crowding.

Arm holding leash appears awkward; introduces new angle.

Leash angle matches leg angle.

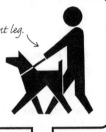

Angle arm matches dog's front leg.

Figure appears more relaxed.

Smooth movement through shapes; ready to proceed to comprehensive stage.

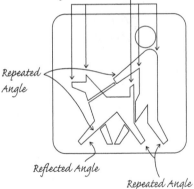

Repeated Verticals

Repeated Angle

Reflected Angle

Repeated Angle

Repeating or reflecting angles or shapes establishes a visual relationship between them.

Comprehensive Stage

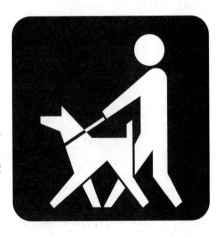

Design is a series of visual relationships. These relationships, or repetitions, keep the viewer's eye "locked" in the design, while simplifying and strengthening its components.

SYS· tems

- *Keep visual element proportions suitable for viewing distance and function.*

- *Most elements in stationery system are typographic.*

A *system is a series* of unified designs that serve as the tangible, visible representations of a company's identity. They range from the business card to the company trucks. One of the primary systems that designers encounter frequently is the business stationery system— letterhead, business card, and envelope. Each piece has a slightly different purpose, yet each looks like part of the same unified design grouping. Consistent identity placement, suitable paper selection, appropriate color choices, and functional system components all make for a successful business system.

Business Stationery System

- Purpose of communication? *Identify company and project accurate image*
- Intended audience?
 Company's business contacts from customers to suppliers
- Viewing environment?
 Hand-held viewing distance; isolated interaction
- How to prioritize information?
 According to function of system component

9 ½″ x 4 ⅛″

3 ½″ x 2″

8 ½″ x 11″

Letterhead

The letterhead carries a written message (the letter) to a recipient. It frames the message and sets the tone; at the same time it provides pertinent information for a return communication. Company information covers approximately 10 percent of the letter's surface area.

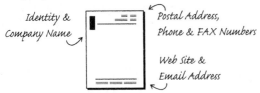

Identity & Company Name *Postal Address, Phone & FAX Numbers* *Web Site & Email Address*

Envelope

The envelope carries the letter to the recipient and also interacts with the postal system. Postal requirements for text placement and envelope size govern its design.

Identity, Company Name, & Postal Address

Business Card

The business card is a form of personal introduction. Company representatives use business cards to introduce themselves accurately to prospective business clients, while providing them with contact information for later reference.

Identity & Company Name *Person's Name & Title* *Web Site & Email Address* *Postal Address, Phone & FAX Numbers*

Paper

Paper is another component that the designer carefully chooses for a stationery system. The paper's quality, texture, and color, held in the recipient's hand, triggers a response before the envelope is opened or the letter read. It establishes an environment and projects a tone or mood representative of the company, appropriate for its customers, and indicative of its product. A motorcycle shop's system, for example, looks markedly different than an upscale women's clothier—different product, customers, and image. ✍

Leave letter area as simple shape for easy insertion.

Design page with comfortable margins.

Choose a typeface that complements identity style.

WORK·sheet
S Y S T E M

- Select display typeface to complement symbol.

- Select text typeface to complement display typeface.

There are two visual elements in a business stationery system—the symbol (or logotype) and the type. Choosing an appropriate type family or two complementary typefaces from different families is an important decision. A suitable choice reinforces the desired mood. An unsuitable choice destroys design unity, resulting in viewer confusion and diminished visual impact.

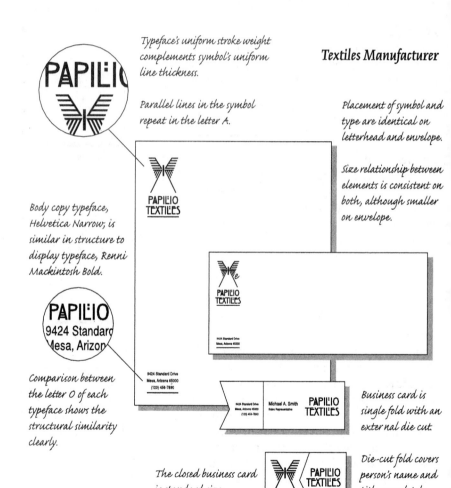

Typeface's uniform stroke weight complements symbol's uniform line thickness.

Parallel lines in the symbol repeat in the letter A.

Textiles Manufacturer

Placement of symbol and type are identical on letterhead and envelope.

Size relationship between elements is consistent on both, although smaller on envelope.

Body copy typeface, Helvetica Narrow, is similar in structure to display typeface, Renni Mackintosh Bold.

Comparison between the letter O of each typeface shows the structural similarity clearly.

The closed business card is standard size.

Business card is single fold with an external die cut.

Die-cut fold covers person's name and title completely.

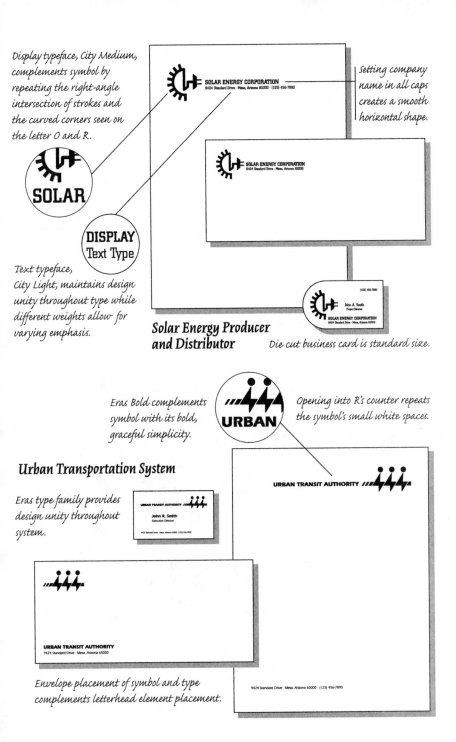

Display typeface, City Medium, complements symbol by repeating the right-angle intersection of strokes and the curved corners seen on the letter O and R.

SOLAR

DISPLAY Text Type

Text typeface, City Light, maintains design unity throughout type while different weights allow for varying emphasis.

SOLAR ENERGY CORPORATION
9424 Standard Drive · Mesa, Arizona 65000 · (123) 456-7890

Setting company name in all caps creates a smooth horizontal shape.

SOLAR ENERGY CORPORATION
9424 Standard Drive · Mesa, Arizona 65000

(123) 456-7890
John A. Smith
Project Director
SOLAR ENERGY CORPORATION
9424 Standard Drive · Mesa, Arizona 65000

Solar Energy Producer and Distributor

Die cut business card is standard size.

Eras Bold complements symbol with its bold, graceful simplicity.

URBAN

Opening into R's counter repeats the symbol's small white spaces.

Urban Transportation System

Eras type family provides design unity throughout system.

URBAN TRANSIT AUTHORITY
John R. Smith
Executive Director
9424 Standard Drive · Mesa, Arizona 65000 · (123) 456-7890

URBAN TRANSIT AUTHORITY

URBAN TRANSIT AUTHORITY
9424 Standard Drive · Mesa, Arizona 65000

Envelope placement of symbol and type complements letterhead element placement.

9424 Standard Drive · Mesa, Arizona 65000 · (123) 456-7890

CHAPTER 19

POST·
ers

- *Review design ideas from correct viewing distance.*

- *Prioritize elements carefully for immediate impact particularly with a moving audience.*

*P*osters are large-format, wide-audience, single-panel communications. They inform people about activities, events, concepts, and positions. Posters announce concerts, sporting events, and political rallies; serve as educational tools within the classroom; and influence public opinion.

A poster is viewed at two distances—from afar and up close. Not everyone sees both views. At a distance the poster attracts the viewer's attention within its surrounding environment. If the viewer never comes any closer, the poster's general purpose should be evident—poster for a sporting event, for example. If the viewer is interested in the topic or intrigued by the poster in general, coming closer communicates the details.

Preschool Educational Poster

- Purpose of communication?
 Vocabulary instruction
- Intended audience?
 Preschoolers learning to read
- Viewing environment?
 *Remote viewing distance
 (3 feet or more)*
- How to prioritize information?
 *Emphasize attention-getting
 characteristics to draw viewer
 closer for details*

14" x 21"

NEGATIVE LEADING

Negative leading is recommended for all-cap headings.

48/42

Negative Leading *When vertical distance between adjacent type lines is smaller than the type size.*

SET SOLID LEADING

Solid leading appears too large for all-cap display type.

48/48

Viewing Environment

A poster's display environment influences its design. Where will it be hung? Is there an excess of visual competition? Does the intended viewing audience rush past, stroll, or sit? These environmental characteristics and others influence the design approach.

Competitive Environment *Control element attributes to isolate poster in distracting environment.*

Audience *Connect quickly with fast-moving audience. Establish poster's purpose in general terms.*

Brightly colored, light-hearted illustration captures children's attention. Page map directs the viewer from the graphic to the word by increasing chicken sizes from top (small) to bottom (large), by repeating left-to-right downward diagonals, and by isolating the words.

Typography

The increased viewing and reading distance of a poster affects the typographic decisions concerning both display and text type.

Display type *Set in larger sizes than hand-held display type and use tighter leading and letterspacing while maintaining optical balance.*

Text type *Set in larger sizes than hand-held text type, use more leading to assist with reading at a distance, and choose a legible typeface.*

Letterspacing noticeable; weakens word cohesion.

KERN
KERN

Kern to decrease letterspacing in large-size display type.

Page Map

With all the information on the same large plane (the poster's surface), it is easy for a viewer to become distracted and not discern the poster's purpose. A designer applies design principles effectively to the visual elements and makes the viewer's journey logical, informative, and free from distractions.

Visuals *Control sizes, repeat shapes, and use diagonals to control viewer's eye movements around plane. A viewer's eye is attracted to repeated shapes due to visual repetition. Use this technique to direct the eye through the page map's prioritized elements.*

Color *Manipulate color attributes (value, intensity, temperature) to enhance and control viewer progress along page map.*

AD·s

- *Design for the viewing environment (cluttered? isolated?).*

- *Project a unified mood with all visual elements that is appropriate for target audience.*

- *Prioritize elements so the viewer gets a summary understanding of the ad's purpose with a brief glance.*

*P*rint-media advertisements in newspapers and magazines are single-panel communications viewed at a hand-held distance. They advertise products and services, announce events and sales, or promote entertainment and eateries. All the information displays simultaneously. Often adjacent ads compete for the viewer's attention on the same or facing pages.

Publications attract serious and casual readers. Serious readers are interested in the majority of articles and have sufficient time to read them. An ad is likely to be seen and read by this committed reader. Casual readers have limited time and just want the highlights. They scan the pages for important information and take what their time and interests allow. The time it takes to open the publication, glance at the spread, and turn to the next one is all the time an ad gets to attract this uncommitted reader. With that environment and these two viewers in mind, the designer uses the strongest visual element as the attention getter and manipulates its attributes to connect with as many readers as possible.

Restaurant Newspaper Advertisement

- Purpose of communication?
 Promote specific restaurant entrée
- Intended audience?
 General public
- Viewing environment?
 Hand-held viewing distance (18 inches) for hurried and careful reader
- How to prioritize information?
 Emphasize entrée illustration to entice viewer to look closer for details

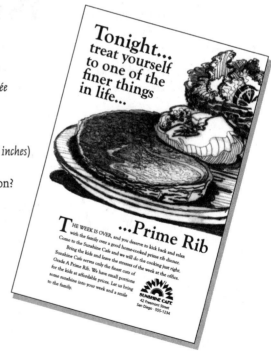

AaBbCc AaBbCc
AaBbCc **AaBbCc**

Formal typefaces suggest factual, precise, official, and sincere information.

AaBbCc AaBbCc
AaBbCc AaBbCc

Informal typefaces suggest fun, lively, casual, off-the-cuff, and unofficial information.

Viewing Environment

An advertisement has both a careful and a hurried readership in a visually competitive environment. The hurried or casual reader leafs quickly through a publication hastily scanning the pages. Each *spread* (two facing pages) receives five to ten seconds of scan-time depending upon the page size, page complexity, and whether or not something catches the reader's attention.

> **Competitive Environment** *Control element attributes to isolate ad and attract attention in multiad environment. Ad has one opportunity to entice viewer and make a connection.*

> **Audience** *Prioritize elements to deliver a summary snapshot of ad's purpose and to entice further audience review.*

A well-designed ad has a tight page map that loops back into the ad keeping the viewer within the ad for as long as possible.

Typography

The viewer's tendency to be hurried accentuates need for typographic harmony with ad's content and visuals. Viewer haste emphasizes the importance of type's attention-getting characteristics.

> **Display type** *Sets tone and complements visual for a unified statement. Type that contradicts mood of ad creates confusion and puts message in doubt.*

> **Text type** *Select typeface that complements display type—lighter-weight family member, such as light or book, or structurally compatible or contrasting. Choose legible typeface and set to enhance readability at hand-held distance. Increased leading for sans serif typefaces improves readability.*

Sans serif type with insufficient leading promotes vertical movement through type lines and lowers readability.	Increased leading emphasizes the horizontal movement necessary for reading by isolating the type lines.

Page Map

A tighter, easy-to-follow page map minimizes distractions from other ads while the reader is engaged. To evaluate the page map, squint at the page for a first impression of the dominant elements or view it from a distance by hanging it on the wall. This enables the designer to distinguish the dominant elements quickly after working with a design for a long time.

> **Elements** *Control sizes, repeat shapes, and use diagonals to control eye movements around plane. Eliminate directional elements that encourage distraction, such as eyes looking out of ad or a visual sequence that does not loop back into the ad.* ✍

WORK·sheet

AD

- *Select typefaces appropriate for time period or complementary to woodcut illustration style.*

- *Illustration focuses on the game of chess.*

A designer can generate many alternate layouts for an event by emphasizing different visual elements. The following layouts advertise a public Renaissance festival. Participants are invited to come and watch or play the popular games from that time period. The emphasis in these layouts varies between the headline and the illustration.

Emphasizes headline.

Agincourt, headline typeface, is appropriate for the time period.

Uses versals in the 14th-century tradition. Descending interconnecting versals designed in the typeface style.

Emphasizes headline and illustrations equally.

Places illustration in squares to suggest a chessboard.

Arranges the square versals and illustrations to suggest a chessboard pattern.

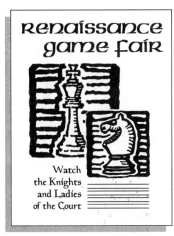

Emphasizes illustration.

Caslon Antique typeface is similar in style to illustration. Both have a wavy, uneven edge.

Emphasizes headline.

Illustration is displayed within a chessboard suggested in perspective.

Headline leads viewer into illustration and then into body copy and subhead through the chessboard perspective.

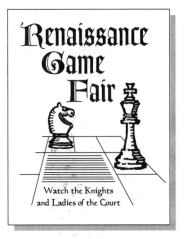

Emphasizes illustration.

Style of woodcut blocks are appropriate for time period.

Typeface, appropriate for the time period, is calligraphic. This handmade style complements handmade illustration style.

CHAPTER 21

BRO·
chures

- *Design all visible panels as a complete unit.*

- *Incorporate the die cut into the design on both sides of the page.*

- *Create a graphic environment for the entire brochure that is consistent from panel to panel.*

Brochures communicate a large amount of information to a single reader at a hand-held viewing distance. Not all the information is presented at once. It is doled out in stages, panel by panel and **spread** by spread, while continuing to keep the viewer interested. The designer determines the placement of graphics and text within each panel according to how the information is prioritized. Prioritizing assures that the reader is drawn into the topic in an understandable way, such as from the general information to the specific. Various brochure folds are possible and provide different panel sequencing of information to the reader.

A brochure's design visually connects all panels into a single environment appropriate for the subject matter and target audience. Each stage is designed as a single entity, but it also serves as part of a continuum—similar to acts in a play or pages in a web site. The challenge in brochure design is how to use the logic of the text and the interest of the graphics to move the viewer through the brochure until the message is delivered in its entirety.

Science Activities Book Series
Brochure Layout
- Purpose of communication?
 Introduce science activity book series
 Brochure possibly kept for reference and later review
- Intended audience?
 Elementary school teachers
- Viewing environment?
 Hand-held viewing distance (18 inches)
- How to prioritize information?
 First panel (front) attracts attention and establishes subject matter. First spread summarizes highlights of books' features. Second spread provides detailed example of one activity.

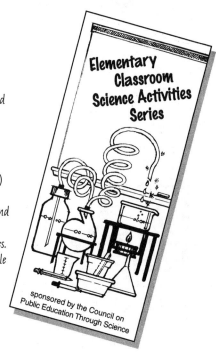

Elementary Classroom Science Activities Series

sponsored by the Council on Public Education Through Science

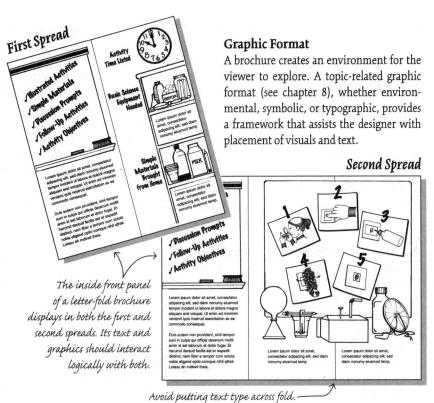

First Spread

The inside front panel of a letter-fold brochure displays in both the first and second spreads. Its text and graphics should interact logically with both.

Avoid putting text type across fold.

Second Spread

Graphic Format

A brochure creates an environment for the viewer to explore. A topic-related graphic format (see chapter 8), whether environmental, symbolic, or typographic, provides a framework that assists the designer with placement of visuals and text.

Die Cut Brochures

An internal or external **die cut** reshapes a simple rectangular brochure and adds another visual element. An *internal die cut* is a geometric or organic shape cut through the paper enabling an interior visual to show through to the front, for example. The shape becomes a visual element within the interior spread as well.

An *external die cut* changes a rectangular brochure into any shape enabling the viewer to interact with it as an object rather than "framed" information on a page. A take-out brochure for a Mexican restaurant shaped as a taco, for example, provides a memorable tactile experience. ✍

Internal Die Cut

External Die Cut

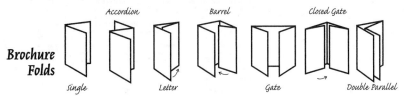

Brochure Folds

Accordion — Single
Barrel — Letter
Closed Gate — Gate
Double Parallel

CHAPTER 22

NEWS·letters

- *Typesetting and typographic design skills are paramount in such a text-heavy design media.*

A newsletter is a cross between a newspaper and a magazine. It disseminates factual information, like a newspaper, about a product, service, organization, or interest group. Like a magazine, it presents in-depth articles on fewer topics, is produced on a monthly or bi-monthly schedule, and has a distinct personality geared to its target audience. Newsletters are used by companies to communicate with their customers, shareholders, and employees. Clubs or organizations also use newsletters to contact their membership concerning activities and articles of interest. Newsletters are an inexpensive way to present a large quantity of detailed information to a targeted audience.

Espresso-Lovers Newsletter Comprehensive
- Purpose of communication?
 Provide subscribers with espresso-related information
- Intended audience?
 Small group of enthusiasts (espresso fans subscribing to publication)
- Viewing environment?
 Hand-held viewing distance (18 inches) for continuous reading
- How to prioritize information?
 By story importance

A QUARTERLY NEWSLETTER FOR LOVERS OF THE BLACK BREW

Elegant Espresso Makers
Art in the Eyes of the Beholder!

ITALY IS HOME TO THE INVENTION of the espresso machine in 1946. Ipsum dolor sit amet, consectetur adipscing elit, sed diam nonumy elusmod tempor incident utew labore et dolore magna aliquam eral volupat. Uteyr enim ad minimim veniami quis nostrud exercitation ultamcorpor suscipit laboris nisi ut aliquip ex ea commodo conse qut. Duis autern vel eum irure dolor in reprehenderit in voluptate velit esse molestaie son consequat , ervel illum dolore eu fugiat nulla pari atur. At vero eos et accusam et justo odio dignissim qui blandit prase sent lupatum delenit airgue duos dolor et molestais.

Excepteur sint occaecat cupidat non prom vident, sinil tempor suni in culpa qui dese officia dese runt mollit anim id est labor et umet dolor fugai. Et harund dereud facilis est er expedit distinct. nam liber a te mporey cum soluta nobis eligend optio comque nihil quod a impedit anim id quod maxim placeat facer possim fromnis estre voluptas assumenda est, omnis dolor repellend. Temporem autem quinsud et aur office debit aut turn rerum necessit atib aepe eveniet ut er repudiand. ()

Espresso machine perfected in 1946

Parma Coffee Bar
Maintains Traditions

Et tamen in busdad ne que pecun modet est neque nonor imper ned libiding gen epular religuard onty cupidat, quas nuita praid im umdnat. Improb parye minuiti potius inflammad ute coercent *Meeting place of Italian* magist andq eter dodecendense *neighborhood* videantur, invitat figitur evera ratio *society* bene santos ad iustitiami aequitated fidem. Neque hominy infant autw inuiste fact est santos bene.

Cond que nege facile pefficerd possit duo conteud nolinery setr effecerit, ett opes vel forunag veling en liberalitat opes magnis em conveniunt babute tutungbene volent sib renj consiliant et, alid appissim est adef quet. Endium caritat praesert cum omning snull siy caus peccand etem quaerer en imigent cupidat a natura proficis facile et explent sine julla inura autent unanc sunt isti. Improb reloparye et minuiti potius inflammad ute coercent magist fidem. ()

The challenge of designing newsletters is mainly typographic; a newsletter is a text-heavy document. The designer determines the typographic treatment for each newsletter component in accordance with its function. By controlling type attributes, such as placement, size, type style, measure, white space, alignment, and leading, the designer determines impact and hierarchy. Subtle attribute changes are enough to differentiate between hierarchical levels.

Nameplate *Typographic identity, like a logotype, for a publication. Placed on first page.*

Tagline *Description of target audience or purpose of newsletter. Can include date and volume number. Low priority information, not visually dominant. Choose typeface complementary to nameplate or matching text.*

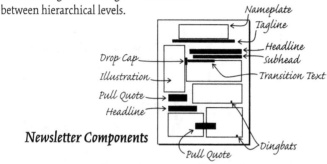

Newsletter Components

Drop Cap *Enlarged first letter of initial paragraph, also called* versal. *Draws attention to beginning of article. Serves as a graphic element. May be embedded in, along side of, or protruding above text. Always align cap and text baselines. Use selectively.*

Transition Text *First few words (12+ letters) set in small caps, regular capitals, or enlarged lowercase. Visually links drop cap to the text type it preceeds. Denotes high typographic quality.*

Pull Quote *Paraphrased idea or point repeated from article. Used and positioned as a graphic element to break up lengthy text. Never hyphenate. Eliminate end punctuation except for question marks and exclamation points.*

Headline *Announces story. Varied placement of heading (across top, on side, embedded in text) provides visual variety while maintaining unity through consistent typeface usage. Use less white space after any heading to link it to its story.*

Subhead *Clarifies headline. Adds another attention-getting element to beginning of article. Typographic treatment secondary to headline.*

Dingbat *Small graphic symbol used to indicate end of article.*

A designer balances variety, when identifying each story as a separate entity, while maintaining document unity, by keeping a similar design approach running through all of the stories. The goal is to create a readable, visually interesting document that appeals to a specific target audience while also avoiding informational chaos. ✍

WORK·sheet
NEWSLETTER

- Design style is influenced by nameplate design, typeface selection, type alignment, and use of white space.

Target audiences for the following newsletters encompass people interested in butterflies and moths. *Lepidoptera* is designed as an international, scientific newsletter for scientists and academics seeking to broaden the factual body of knowledge concerning butterflies and moths. *Flights of Fancy* is designed as a newsletter for a regional audience of hobbyists. This group is interested in organized outings, fundamental information, and butterfly-related issues and stories.

Replaced with rotated, shortened comma to relate to diagonal endings.

Redesigned to match ending of lowercase j. Breaks the word's vertical monotony and functions as contrasting, unifying design element.

Officina Sans has similar proportions to nameplate typeface. Appropriate for content due to design simplicity and high legibility.

24-point Officina Sans Bold. Largest headline for most important story. Establishes text hierarchy.

More white space is placed before heading (and less after) to visually link it with paragraph it introduces.

Table of contents useful for multipage newsletters.

Technical illustrations use enlargements to clarify study findings.

Grabbers set in 11/12 italic book weight.

Justified alignment is formal and suggests factual information.

Baselines in adjacent text columns align to avoid visual clutter.

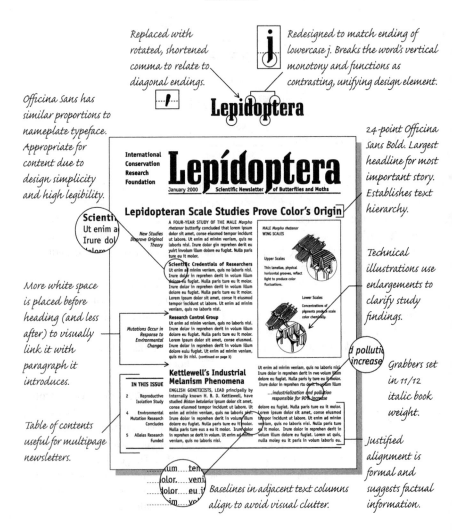

Lepidopteran Scale Studies Prove Color's Origin

International Conservation Research Foundation

Lepídoptera
January 2000 Scientific Newsletter of Butterflies and Moths

A FOUR-YEAR STUDY OF THE MALE *Morpho rhetenor* butterfly concluded that lorem ipsum dolor sit amet, conse eiusmod tempor incidunt ut labore. Ut enim ad minim veniam, quis no laboris nisi. Irure dolor gin reprehen derit eu yuirt involum illum dolore eu fugiat. Nulla paris ture eu it molor.

Scientific Credentials of Researchers
Ut enim ad minim veniam, quis no laboris nisi. Irure dolor in reprehen derit in volum illum dolore eu fugiat. Nulla paris ture eu it molor. Irure dolor in reprehen derit in volum illum dolore eu fugiat. Nulla paris ture eu it molor. Lorem ipsum dolor sit amet, conse it eiusmod tempor incidunt ut labore. Ut enim ad minim veniam, quis no laboris nisi.

Research Control Group
Ut enim ad minim veniam, quis no laboris nisi. Irure dolor in reprehen derit in volum illum dolore eu fugiat. Nulla paris ture eu it molor. Lorem ipsum dolor sit amet, conse eiusmod. Irure dolor in reprehen derit in volum illum dolore eulu fugiat. Ut enim ad minim veniam, quis no lis nisi. (continued on page 3)

Kettlewell's Industrial Melanism Phenomena
ENGLISH GENETICISTS, LEAD principally by internally known H. B. D. Kettlewell, have studied *Biston betularius* ipsum dolor sit amet, conse eiusmod tempor incidunt ut labore. Ut enim ad minim veniam, quis no laboris nisi. Irure dolor in reprehen derit in volum illum dolore eu fugiat. Nulla paris ture eu it molor. Nulla paris ture eus a eu it molor. Irure dolor in reprehen se derit in volum. Ut enim ad minim veniam, quis no laboris nisi.

Ut enim ad minim veniam, quis no laboris nisi. Irure dolor in reprehen derit in rwe volum illum dolore eu fugiat. Nulla paris iy ture eu it molor. Irure dolor in reprehen rto derit in volum illum

...industrialization and pollution responsible for 90% increase

dolore eu fugiat. Nulla paris ture eu it molor. Lorem ipsum dolor sit amet, conse eiusmod tempor incidunt ut labore. Ut enim ad minim veniam, quis no laboris nisi. Nulla paris ture eu it molor. Irure dolor in reprehen derit in volum illum dolore eu fugiat. Lorem ut quis, nulla moley eu it paris in volum laboris eu.

MALE *Morpho rhetenor* WING SCALES

Upper Scales
Thin lamellae, physical horizontal grooves, reflect light to produce color fluctuations.

Lower Scales
Concentrations of pigments produce scale color chemically.

a pollution increase

New Studies Disprove Original Theory

Mutations Occur in Response to Environmental Changes

Scientific Credentials
Ut enim a
Irure dol

um ten
olor. veni
olor. eu i
im vo

FLIGHTS OF FANCY
Original nameplate thumbnail

FLIGHTS OF FANCY
Original typeface, Rennie Mackintosh Bold

A **nameplate** is a logotype. This design form requires structural letter alterations to balance the entire design.

Shortened crossbar improves letterspacing and repeats at foot of Y.

Swash of S repeats for balance in C.

FLIGHTS OF FANCY

Interlocking letters improves letterspacing.

Dot of I repeats in N for balance.

Curved bar of A repeats in H.

Increased white space draws attention to beginning of first article.

Condensed text type, Boton Regular, requires additional leading (9/12) to improve readability.

Increased white space between paragraphs replaces first-line indents to introduce new paragraphs.

Table of contents creates butterfly's path for informal presentation.

FLIGHTS OF FANCY

MARCH 2000 • SACRAMENTO LEPIDOPTERA SOCIETY

Roosting Butterflies in Cages 4 • Camouflage 2 • Poisonous Butterflies

INSIDE THIS ISSUE: Journal

journal. To looker needs in the woods.

or incidunt ut nisi. Irure dolor

THE DEDICATED LEPIDOPTERAN looker enjoys trooping through fields and marshes in search of new sightings to add to his or her journal. To chronicle these occurrences, a dedicated looker needs the proper equipment when out in the woods.

Field Equipment for the Flighty Hobbyist

Gear Up for Summer with the Right Gear

Lorem ipsum dolor sit amet, conse eiusmod tempor incidunt ut labore. Ut enim ad minim veniam, quis no laboris nisi. Irure dolor gin reprehen derit eu yuirt involum illum dolore eu fugiat. Nulla paris ture eu it molor. Lorem ipsum dolor sit amet, conse eiusmod tempor incidunt ut labore. Ut enim ad minim veniam, quis no laboris nisi. Irure dolor gin reprehen derit eu yuirt involum illum dolore eu fugiat.

Ut enim ad minim veniam, quis no laboris nisi. Irure dolor in reprehen derit in volum illum dolore eu fugiat. Nulla paris ture eu it molor. Irure dolor in reprehen derit in volum illum dolore eu fugiat. Nulla paris ture eu it molor. Lorem ipsum dolor sit amet, conse it eiusmod tempor incidunt ut labore. Ut enim ad minim veniam, quis no laboris nisi ert yupert dolor ad minus.

Ut enim ad minim veniam, quis no laboris nisi. Irure dolor in reprehen derit in volum illum dolore eu fugiat. Nulla paris ture eu it molor. Lorem ipsum dolor sit amet, conse eiusmod. Irure dolor in reprehen derit in volum illum dolore eulu fugiat. Ut enim ad minim veniam.

Field Gear

Planting a Butterfly Garden

Lorem ipsum dolor sit amet, conse eiusmod tempor incidunt ut labore. Ut enim ad minim veniam, quis no laboris nisi. Irure dolor gin reprehen derit eu fugiat. Nulla paris ture eu it molor. Lorem ipsum dolor sit amet, conse eiusmod tempor incidunt ut labore. Ut paris ture eu it molo

rem ipsum dolor sit amet, conse eiusmod tempor incidunt ut labore. Ut enim ad minim veniam, quis no laboris nisi. Irure dolor gin reprehen derit eu fugiat. Nulla paris ture eu it molor. Lorem ipsum dolor sit amet, conse eiusmod tempor incidunt ut labore. Ut enim ad minim veniam, quis no laboris nisi. Irure dolor gin reprehen derit eu yuirt involum oyt royur. Ut enim ad minim veniam.

Attract Butterflies to You!

act rep eu fu ipsur flies ou! inc

11/16 Boton draws attention to start of article by its larger point size and leading.

Informal, sketchy illustration style is suitable for content.

Rule establishes boundaries of second article.

Flush left alignment is informal and suited to general-interest information.

Grabber baselines (12/18) align with text baselines (9/12) every other line.

Rule clearly defines end of page, used as a unifying element on all pages. Repeats from nameplate.

CHAPTER 23

FIN·ished ART

*D*esigners play a major role in the design process, but they are intermediaries. The designer alone cannot provide the client with a printed brochure, and the printer cannot produce the brochure without first receiving the finished artwork from the designer. Designers facilitate the linkage between client and printer while providing the visual design solution needed by both.

Finished art refers to artwork properly prepared for reproduction. It includes the markings, tolerances, specifications, and instructions necessary for the printer to create all the color-separated plates needed by the printing press. Prepress procedures are exacting. They require careful attention to detail to ensure that no mistakes alter the final printed piece. On some jobs the designer does a press check during the printing run to check for color fidelity and print quality.

Finished art uses standard symbols and techniques that give the printer a wealth of information about preparing the job for the press. *Crop marks* indicate the final size or **trim edge** of a rectangular-shaped piece. When printed on a larger piece of paper, for example, crop marks show the printer where to cut, or trim, the printed piece to its final size. For a nonrectangular-shaped piece the designer creates a *die line*, which is used to create a die, like a cookie cutter, that cuts the printed piece into its final shape.

Fold marks are similar in appearance to crop marks except they are dashed, rather than solid, lines. A fold mark indicates the location of the fold on a printed brochure, for example.

Finished art for rectangle prepared with bleed.

Image within crop marks remains after trimming.

Bleed and crop marks are discarded after trimming.

Single-Sided, Two-Spot Color, 2" × 1¼" Pocket Insert for Garments

= PMS 286 (blue)
= PMS 485 (red)

Crop Marks

Register Mark

Bleed

Composite print of finished art with bleed and printer's marks.

Register marks are symbols used to accurately align colors during printing or films during plate preparation. During prepress procedures for a three-color job, for example, each of the three colors is converted to a separate printing plate. Each color is printed individually onto the paper. The register marks help the printer accurately align the colors, so color placement on the paper is exactly as the designer intended.

Bleeds are used when a shape of color is designed to print right up to a trimmed or die-cut edge. The bleed, a ⅛-inch extension of the color shape extending beyond the crop marks or die line, insures that a sliver of unprinted paper is not visible between the edge of the colored shape and the edge of the printed piece. The bleed itself is actually cut away and disposed of after the piece is trimmed. In the reverse, a ⅟16-inch tolerance is left between the trim or die-cut edge and a color shape in order to prevent any portion of that shape from being cut away during trimming.

Trapping is another technique that controls *color registration* (accurate color positioning on the page). When two colors butt up against one another, inaccurate registration can leave a sliver of paper color between them. To prevent that, either the designer, in the finished art, or the printer, during prepress procedures, extends one of the two color shapes a small amount into the other. This small color extension provides for a margin of error in printing that will not alter the visual effect desired in the printed piece. There are two forms of trapping. A *spread*

Finished art for stop-sign sticker prepared with bleed

Die line used to make die that cuts octagonal shape

Stop-sign sticker after die cutting is complete

Bleed discarded after trimming

PMS 286 color separation

PMS 485 color separation

extends the lighter color shape into the darker, and a *choke* extends the darker shape over the lighter.

Another valuable indication identifies the spreads of a folded brochure, for example, as *inside* and *outside*. When executing finished art for a letter-fold brochure, the outside spread is created as one piece of finished art and the inside spread as another. *Outside spread* and *inside spread* should be noted clearly. Also, with a rectangular-shaped piece the orientation (up or down) might be unclear to the printer who is not as familiar with the project as the designer. Consequently, it is helpful to mark *top* and *bottom* to prevent unintentional error when the spreads are brought together on the same piece of paper.

After the finished art is completed, the designer should check the work carefully by printing out each color separation and carefully reviewing it for accuracy. (All elements on each separation will appear as black or a tint of black no matter what color they represent.) Are all elements for each of the job's colors displaying on their separation? Anything missing? Is the number of separations correct, or is there an extra? Are

Two-Spot Color,
3½" × 2⅝" External and
Internal Die Cut,
Single-Fold Hang Tag
for Garments

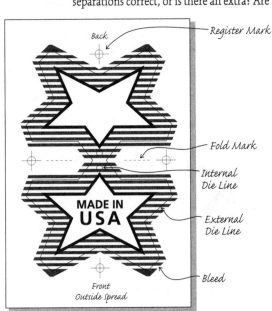

Composite print of finished art with bleed, die line, and printer's marks.

the colors indicated correctly? Does the bleed extend ⅛-inch beyond the trim or die-cut edge? Are the dimensions indicated by the crop marks correct? There are many, many ways in which the printed separations might not match what the designer intended. A created bleed can be cut off by the software if a setting is overlooked, for example. Nothing is better than a careful eye and a ruler for double checking all the tolerances and markings required on finished art.

When preparing to hand off a job to the printer, the designer must check carefully that all of the pieces of the job are available. The printer needs the digital file, its fonts, its graphics, a composite color print, and the color separations. All of the proper approval checks from the client, designer, and anyone else authorizing its printing are needed before the printer gets to work. ✍

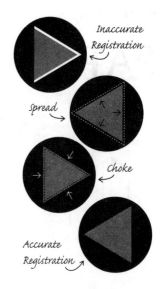

Inaccurate Registration

Spread

Choke

Accurate Registration

Die line for external and internal die cuts

Color separation for PMS 286 (blue)

MADE IN USA

Color separation for PMS 485 (red)

CHAPTER 24

PAP·er

Folding with the grain creates a smooth, strong fold.

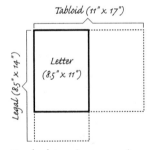

Folding against the grain creates a rough, weak fold.

Standard American paper sizes and their relationship to one another

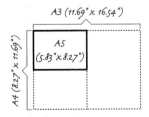

Standard British paper sizes and their relationship to one another

*P*aper is the presentation vehicle for most print media. It is folded, scored, perforated, trimmed, and die cut. Paper, also called **stock**, affects the quality of the printed image and introduces a tactile component to the design. Paper color affects the appearance of halftones, tints, and the ink color itself. Offset lithography inks are somewhat transparent, and the printed color is altered by the paper's color.

Paper is made from various sources, including wood, cellulose, cotton, rags, and recycled paper, depending upon its intended use. These materials all contain fibers. Longer fibers indicate higher paper quality. During manufacture the majority of these fibers align in a single direction, called the **grain**. Grain affects paper's strength and how it folds, tears, and lays flat. By folding *with* (in the direction of) the grain, the fibers provide a guide, or straight channel, for the fold to follow, creating a straight, smooth folded edge. Books are bound along the grain, so the pages roll nicely when turned and then lie flat. To fold or tear *across* the grain requires fibers to break. All fibers, however, break at their own point of weakness. This results in a jagged fold or an uncontrolled tear.

Paper Characteristics

A designer consults with a paper distributor or printer to determine the best paper for a project. There are several paper characteristics to know for these discussions: **grade**, **basis weight**, **finish**, **opacity**, and **bulk**.

Grades categorize paper according to use and suggest an approximate weight range from thin to heavy. Newsprint is a thin, lower quality paper grade suitable for a daily, short-term-use publication. Writing grade refers to thin papers such as bond, ledger, and business papers that accept ink well and are easily erased and handled. Book grade refers to medium-weight papers, such as text and offset, and includes the widest range of papers for printing. Cover grade refers to heavy-weight papers used for book covers and folders.

Basis weight more accurately specifies a paper's weight within a single grade. Basis weight, measured in pounds, is determined by weighing a *ream* (usually 500 sheets of paper) cut to a grade-specific size. For example, weighing

a ream of 17-inch-by-22-inch writing-grade paper sets the basis weight for those sheets. Once the ream is cut and packaged for sale, that basis weight is indicated on each package. As a result, a sheet of 20-pound writing-grade paper is thinner than a sheet of 28-pound writing paper.

Finish refers to surface texture and ranges from smooth to coarse. A finish is visible to the eye as a pattern of lights and darks. It is also tactile, discernable to the touch, as a series of highs and lows. Terms such as *laid, felt, antique, linen, cambric, emboweave,* and *canvas* are common paper finish names. The choice of paper finish is a design decision. A suitable selection projects the right mood and complements the design, type, and illustration styles for an effective printed piece.

Finishes also include surface coatings that affect how the paper receives ink and the resulting print quality. Coated paper is treated with substances that seal the fibers, smooth the surface, and limit ink absorption. Inks printed on coated paper display better color fidelity and print with sharper definition, and they may appear glossy. Uncoated paper allows printing inks to be absorbed into the paper fibers, thus muting the color and giving it a matte appearance. A delicate piece of line art or a light typeface prints more accurately on a smooth coated surface than a coarse textured one.

Opacity refers to paper's visual density. High opacity prevents a printed image on one side from showing through to the other.

Bulk measures the thickness of paper in pages per inch (ppi). This characteristic is of concern to book publishers, for example. Papers with a high bulk create thicker books, requiring more room on the shelf and more shipping boxes for distribution than the same book printed on paper with a lower bulk.

Choosing the right paper is another decision that enhances the design of a printed piece. The right color and finish add a touch of class to a sophisticated design; brightly colored felt-finish stock makes a brochure for kids feel familiar, and a white, glossy, coated stock makes the products in a halftone-filled catalogue look dazzling. Paper adds the finishing touch to a printed piece. ✑

Cambric Finish

Canvas Finish

Felt Finish

Leather Finish

Opacity determines whether a printed image (left) shows through to the back side (middle) of the sheet or remains unseen (right).

Bulk is a vertical measurement of a stack of paper sheets.

CHAPTER 25

PRINT·ing

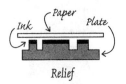

Relief

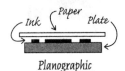

Planographic

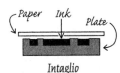

Intaglio

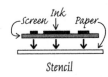

Stencil

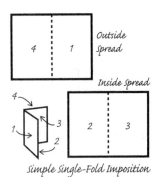

Simple Single-Fold Imposition

*P*rinting is the act of transferring ink from a printing plate or its equivalent to a recipient surface or the act of making an impression. Printing occurs on a variety of two- and three-dimensional surfaces including paper, metal, glass, fabric, and plastic. There are four major printing methods: **letterpress**, or *relief*, **offset lithography**, or *planographic*, **gravure**, or *intaglio*, and **screenprinting**, or *stencil*. Different printing processes are more suited to certain printing surfaces, while others have strengths that make them more suitable for specific jobs, such as long print runs, high-quality halftones, extra-wide printing capabilities, and so forth.

A fundamental difference between the four processes is how each defines the area on the printing plate to receive ink for transfer. The term *plate* describes all flat, cylindrical, or masked mesh screens used to transfer ink to a printable surface. These ink-receiving areas (shapes, type, halftones, rules) are created by the designer on the finished art. The inked areas on the plate are either raised for letterpress, recessed for gravure, chemically defined for offset lithography, or left open for screenprinting. Once the plate is inked, the ink-receiving areas retain the ink (or let it pass through) and transfer it to the paper.

Paper enters a press in one of two ways: one sheet at a time, *sheet fed*, or as one continuous length from a large roll, *web fed*. The term *web* refers to the series of rollers at the head of the press that maintains correct tension on the paper as it enters the press. Presses can print a single color or multiple colors. Each color has its own color unit where each ink is loaded into its fountain and its printing plate is attached. A sequence of four units constitutes a four-color press. *Perfecting presses* print on both sides of the paper simultaneously.

Before a plate is prepared for a multiside document, the printer determines how the art should be positioned on the plate to minimize paper waste. This procedure, called **imposition**, requires precise registration and is influenced by paper size, press size, and number of document pages.

Each printing process has its own specific platemaking technique. Many use a photomechanical process. The finished art is converted to several film negatives depending

Principles of Photomechanical Platemaking

Finished Art
(Black on White)

Film Negative

Photosensitive plate
exposed to light
through negative

upon the number of colors or special exposures required. A *film negative* is a piece of acetate that defines the printing images as shapes of clear film and the nonprinting areas as shapes of opaque black film. The negative is positioned on top of the printing plate whose surface is completely covered with a light-sensitive coating. A high-intensity light beam then passes through the clear areas on the film exposing the coating below. The light is blocked by the film's opaque areas. During chemical developing, the exposed area is prepared to receive ink according to the requirements of the intended printing process. Not all platemaking uses a photomechanical process. Some offset lithography and gravure plates are created directly from digital files, thus saving a step and minimizing registration errors.

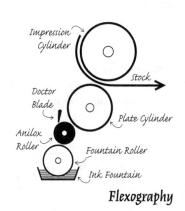

Flexography

Letterpress

Letterpress is the oldest form of mechanized relief printing. Raised areas on the plate receive ink from the ink roller; the recessed areas, due to their location, do not. Woodcut and linocut printing are simple forms of relief printing. While letterpress itself is no longer widely used, a form of letterpress called **flexography** is used in the packaging industry for milk cartons, gift wraps, plastic bags, and corrugated boxes. Flexography uses flexible rubber or photopolymer plates that are adhered to the plate cylinder. This process prints on a variety of substances, is well suited for large areas of contiguous color, and is suitable for long print runs (millions of impressions). It is not suitable for halftones and reversed-out or small type, due to a tendency for the printed image to spread.

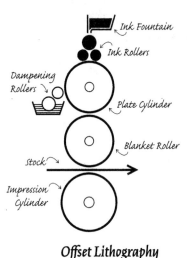

Offset Lithography

Offset Lithography

Offset lithography is the most popular form of printing for business and commercial uses. Printing plates are made of paper, plastic, or aluminum and are rated by number of impressions. Many offset plates are produced photomechanically. During chemical development, the exposed photosensitive resin coating hardens and becomes chemically sensitized to repel water and attract ink. The unexposed coating washes off after development, making these areas attractive to water. The chemical reaction of ink and water repelling one another is the cornerstone of this process, which enables the printing and nonprinting areas to be on the same flat plane.

Lithography, invented by Aloys Senefelder, printed directly to paper from large chemically treated limestone slabs. Offset lithography, however, *offsets* (transfers) the image first to a flexible rubber blanket roller and then prints it to paper. Offsetting the image is important for two reasons: It protects the plate's resin coating from abrasion by the paper's surface, extending the number of impressions possible from a single plate, and the blanket roller's surface is pliable and conforms to the paper's surface, producing a better quality impression to a wider range of finishes.

Gravure

Gravure printing uses an intaglio technique similar to that of etchings and engravings. With gravure, the ink-receiving areas are divided into *cells,* small recessed ink-holding units. These cells are etched

Principles of Offset Lithography

Right-reading printing plate

Plate dampened then inked

Inked image transferred to blanket roller

Blanket roller prints to paper

Printed image on paper

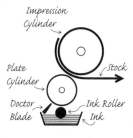

Gravure

or engraved into a metal cylinder that serves as the printing plate. Cells may vary in depth and size and, as a result, produce areas of different ink densities. Once the plate is covered with ink, a doctor blade scraps the surface removing the ink from the highest surface. The paper is then forced into contact with the ink in the cells by the rubber-coated impression cylinder. The plates used in gravure are very durable and good for high speed runs (3,000 feet per minute) of over a million impressions. Gravure is noted for its superior halftone reproduction, making it popular for magazine printing and catalogues, as well as for printing wide surfaces (up to 150 inches), such as vinyl floor coverings and textiles.

Screenprinting

Screenprinting is a form of stencil printing. The plate consists of a stencil image adhered to a fiber screen (silk or polyester) or metal mesh. The ink-receiving areas on the screen are open to enable ink to pass through to the paper below. The stencil covers the non-printing areas and obstructs ink flow. Commercially, stencils are made photomechanically or are cut by plotters. Screenprinting offers versatility. It is good for short runs as well as runs up to 15,000 impressions. It prints a thick opaque covering of ink suitable for printing dark surfaces and creating unusual effects. It is used to print computer circuit boards, compact discs, fabrics, and other unusual items. It is not recommended for delicate type and halftone printing or for items requiring precise registration.

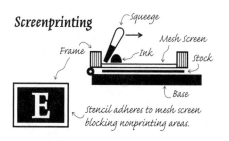

stencil adheres to mesh screen blocking nonprinting areas.

Printing with ink is not the only thing accomplished on a press. *Varnishes* are applied in much the same manner as ink and create a glossy or matte shaped area. *Thermography* is a technique of adding resin to and then heating wet ink, causing the area to rise like an engraved image. Presses are also used to emboss, perforate, score, die cut, and foil stamp paper within the course of a print job. Knowing what is available from the printer and the press expands the designer's range of ideas for presention to a client. ✍

CHAPTER 26

WEB
pages

- *Keep pages simple and uncluttered.*

- *Design for screen proportions.*

- *Apply design principles consistently.*

- *Control text-type attributes to enhance readability.*

Web pages bring the presentation of extensive amounts of information to the electronic viewing environment. They provide a staggering breadth of information concerning business, health, education, entertainment, financial, and commercial topics. Nowhere is such a large amount of information accessed through such a small portal—a web browser on a computer. Web pages can be part of a larger *web site*, a designed interconnected system of pages pertaining to a common purpose or topic. They are designed for a single viewer as an immediate on-screen reference or for downloading and printing for later reading.

Web designers might work as part of a team of programmers and marketing specialists to determine the distribution of information within the page and site. Others might work alone with a client explaining what is possible and offering suggestions for the site's planning. Much depends on the size of the client's budget and extent of the client's involvement in web-based communications.

Culinary Herb Web Page

- Purpose of communication?
 Introduce culinary herb web site, identify intended audience, and indicate web site features
- Intended audience?
 Web users interested in cooking with and growing herbs

- Viewing environment?
 Computer-screen distance (24 inches) for online reading
- How to prioritize information?
 Attract attention and establish site's purpose; start to channel viewers to desired information within site

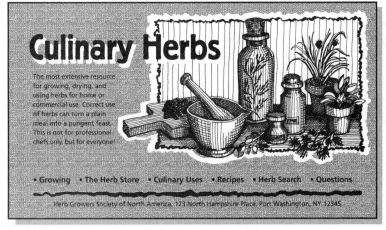

Although web-page design is a more recent application of design principles than print media, the two share common elements and design concerns. A web-page designer uses the visual elements along with audio and animation capabilities to communicate to the viewer. The web designer applies design principles and manipulates element attributes to structure and prioritize the web-page content. The needs and preferences of the target audience also influence the design and typographic treatment.

Many web pages contain a high percentage of text type requiring judicious consideration of text readability. Type size, style, leading, measure, and alignment for this distance and viewing environment are major concerns. Unlike brochures that are kept for later reference, web pages can be more cumbersome to access for a return visit. It is very important to deliver the message on the first visit.

Web-page formats differ from print-media formats in a fundamental way. A print-media page is part of a larger, horizontal *spread*, two adjacent pages designed as a unified whole. Additional information comes from the side by turning a page or opening a panel. A web page has a vertical format accessed by scrolling. The total page design is broken into segments seen one at a time in the available viewing area. In this isolating viewing window the most important information should appear at the top of the page and fill the screen first. The second page segment, found by scrolling downward, contains lower priority information, since not all viewers will see it. The principles of grid structure, unifying color, consistent typography, and overall unified treatment of elements makes the viewer accept this unfamiliar format.

These separately viewed segments of the page also function as stand-alone designs presenting information at a single glance. The viewers' ability to understand the design of the page, its purpose, and how the information is prioritized determines whether they scroll downward, go forward to another linked page, or abandon the site.

As with any other form of visual communication, design is the structure that organizes information and enables the viewer to consume it easily, remain engaged, and be willing to continue. 🙢

535 Pixels = Page Width for Downloading to Print

295 Pixels

595 Pixels = Page Width for Maximum Screen Width

Break page into two segments to minimize scrolling. First segment contains what all viewers should see first.

Second segment contains simpler, lower priority information. Not all will see.

Print-media page design has a horizontal format.

WORK·sheet
WEB PAGE

- Use design elements consistently to unify site.

- Design site for type of user and kind of use.

- Readability is influenced by screen resolution, legibility of typeface, type attributes, and color contrast.

The Urban Transit Authority site is a reference site designed to be simple and direct. It is intended to be accessed by all levels of Internet users seeking specific information concerning fares, routes, and special services. Its appearance is unified by its typography, graphic treatments, and page design.

Design for headers on internal pages based on Urban Transit Authority symbol — repeats dashed line, arrowhead repeats human body style, and bull's-eye circle refers to head.

Header used as consistent design element on all pages for identifying page topic. Use of type as part of header graphic provides consistent typographic design element.

Hot links to four major internal pages.

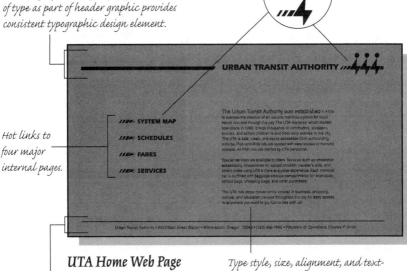

UTA Home Web Page

Type style, size, alignment, and text-wrapping capabilities determined by page-coding specifications.

Footer is another unifying design element. Identifies company name and address on home page and is used as navigational bar on internal pages.

Site Map

System Map Page
Single image screen with no scrolling capabilities

Select links on map access enlargment with street identification.

Fares Page
Both frames scroll independently.

Frames offer easy access to frequently changing information.

Schedule Page
Schedule chart scrolls.

Copy explaining chart is always visible.

Size of scrolling frame prints easily

Services Page
Entire page scrolls.

Header and footer remain stationary during scrolling, as on all other pages within site.

CHAPTER 27

PRE·sen·
TATIONS

- *Keep pages simple and uncluttered.*

- *Make text readable and hierarchy obvious.*

- *Apply design principles consistently.*

- *Use special effects sparingly to focus impact.*

A *digital presentation is a series* of projected frames containing typographic and visual information. It instructs, enlightens, persuades, or influences a group of people at a distance, such as in a conference room or auditorium. It may hit topic highlights to trigger later discussion or present detailed information fostering immediate interaction. A presentation accomplishes its goal with an easy-to-grasp manner free from distracting clutter, annoying effects, and confusing visuals.

Planning a presentation requires understanding its function, environment, and target audience to help focus its design. There are a few general guidelines to keep in mind. Number of frames, ideally, ranges from 15 to 35 depending on quantity of information. Consistent, effective treatment of the visual elements unifies the whole. An internal structure, such as a grid, unifies the placement of the elements but enables flexibility to prevent monotony. A unified design structure is easier to impose when the information is streamlined and concise, rather than busy and cluttered. Abbreviations in some contexts should be avoided, since they can suggest an informal or rushed mood. The visual effect of the whole (formal, informal, polished, or haphazard) influences the audience's acceptance of the content.

Moundbuilder Instructional Presentation

- Purpose of communication?
 Instruct students in history and traditions of American Indian moundbuilder society
- Intended audience?
 Small group of advanced students
- Viewing environment?
 Projected onto large screen in small classroom
- How to prioritize information?
 Using 35 frames, start with general societal introduction leading into specific burial rites and imagery

Frame introduced bird-imagery subsection and functioned as a chapter title page.

Peregrine falcon pipe

Birds in Adena and Hopewell culture

symbolized important element in spiritual beliefs
of Adena and Hopewell

A large percentage of the visual elements in a presentation are typographic. Selection of the right type family sets the appropriate tone or mood for the presentation, as does the style of the graphics. Through the proper use of size, weight, leading, and style the designer can prioritize and emphasize the information as necessary. No more than two type families should be used.

Type in this context is meant to be read. The designer selects sizes proportional to one another and checks the size selection as a projection before making the final choices. Large quantities of type set in bold, italic, or all caps should be avoided. Letterspacing and word spacing are set tight, as on posters. Due to the type's large viewing size, all spacing is enlarged. Any spacing irregularities are distracting and should be eliminated. Avoid typographic clutter by eliminating underlining, drop shadows, and unnecessary punctuation, such as line-end hyphens and terminal punctuation on bulleted items.

Graphics follow similar guidelines. A single style unifies. Two styles are possible, such as combining colored illustrations or photographs with line-art detail magnifications. The graphic file format for these should load and display quickly. It is easy to overlook the type in graphics. A readable size in the same or complementary style as the rest is required.

When selecting color, plan a unified scheme that complements the content of the presentation, such as earth tones for nature-related topics. Color distinctions should be easily apparent. Multiple tints of the same color can be indistinguishable when displayed. Applying colors consistently throughout reenforces the hierarchy established by the type and creates a hierarchy within the graphics. Background colors should function in the background, be soothing to the eye, and not cause the smaller elements to vibrate on screen. Color supports content and hierarchy, but if chosen incorrectly it can physically tire the viewer's eye causing the viewer to lose interest.

Presentations are an exciting visual design environment. They challenge the designer's ability to control the visual elements and apply design principles for communicating with a small, interactive target audience. ✌

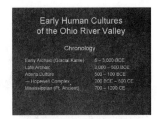

First frame establishes broad cultural time periods.

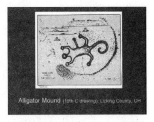

Demonstrates culture's geographic understanding of region.

Presents effigy pipe used to communicate with spirits.

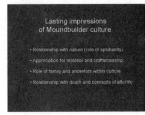

Final frame summarizes cultural impact.

CHAPTER 28

VID·eos

- *Design how and when the viewer sees the images.*

- *Make text readable and hierarchy obvious.*

- *Use special effects to improve impact, not confuse.*

Videos integrate visual elements with a time-based, linear construction. Live action, audio, animation, stills, illustrations, graphics, color, and type are incorporated into a scripted visual progression with a beginning and an end. A video can present a narrative story with a plotlike structure or a sequencing of visuals as an artform. Videos sell, instruct, persuade, entertain, inform, or define an experience. They are used as commercials, feature films or shorts, experimental art, video greeting cards, animated sequences, and as training tools. Video design connects well with viewers who cannot read or who comprehend information more easily in spoken and pictorial, rather than written, form.

Video as a presentation media is unique and has its own history and craft. The design process used for other media and that used when designing the video are similar. Issues regarding purpose of communication, intended target audience, viewing environment, and how to prioritize the information help focus the design's development. A form of layout, called a *storyboard,* helps the designer structure a design sequence. Experimentation with ideas from research come together in the draft storyboard phase as the designer brainstorms ideas in thumbnail form. The final storyboard serves as a design and pacing blueprint for filmed sequences, assembling live-action segments or animations into a coherent whole.

Manipulating element attributes and the timed pacing of their appearance enables the designer to control the viewer's visual field and his or her movement through it. Will the images create a sense of urgency by coming at a rapid-fire rate or an atmosphere of calm by proceeding at a leisurely pace? Will the colors support the tension by being intense and jarring or seek to soothe by being harmonious and tranquil? The designer can present images, including type, as emerging from any direction and at varying speeds. This directional flow and pacing can emphasize forward motion of the traditional reading path or use other patterns. Choice of typeface, issues of weight, ledgibility, readability, and number of type families are concerns here also.

The similarities between the various applications of design are far greater than the differences. Production techniques vary considerably, and the end products are presented in unique ways, but the means to communicate with viewers share common fundamental principles. ༄

Design PRO·fession

Ivan Chermayeff, award-winning graphic designer, described the role of a professional designer as follows: "Design comes from a combination of intelligence and artistic ability. A designer is someone who should solve problems. He is a borrower, co-ordinator, assimilator, juggler, and collector of material, knowledge and thought from the past and present, from other designers, from technology and from himself.

His style and individuality come from the consistency of his own attitudes and approach to the expression and communication of a problem. It is a devotion of the designer to the task of fully understanding the problem and then expressing those ideas which come from this search in its appropriate form that makes him a professional."

PRE·
pare

- *The first job in a chosen field is only the first step in a journey through a career.*

Seeking an entry-level position in a new field is the most nerve-racking of job searches. A good entry-level position serves as a stepping stone or an apprenticeship. It adds to the skills and experience an employee can offer the next employer. With success and career planning, eventually an employee can attain the job desired with the level of responsibility preferred.

Finding a job is like learning to walk—first one tentative step and then another more confident step. A job search is a series of steps that lead to a job or, in this case, into a profession. With each progressive step, confidence and the likelihood of success increase. Progressing from one step to the next denotes success. It shows that the candidate is still under consideration. Most employers take their time when considering candidates, not relying on one meeting or one form of contact. If they are making a long-term commitment to the employee, they will approach the employee-search process with careful deliberation.

Job Search Steps

☐ Prepare résumé.	☐ Initiate follow-up contact.
☐ Prepare portfolio.	☐ Secure interview.
☐ Promote job availability.	☐ Present portfolio.
☐ Identify job opportunity.	☐ Secure second interview.
☐ Research company.	☐ Receive job offer.
☐ Initiate first contact.	☐ Evaluate job offer.
☐ Submit résumé.	☐ Respond to offer.

The Employer's Perspective

When looking for a job it is easy for a prospective employee to focus exclusively on what *he* wants or what *she* needs. How much does it pay? How much design responsibility does it offer? Where is it located? What are the hours? What are the benefits? While all these are important, they represent only one side of the process. The other side, the employer, has questions too. Can the candidate create under pressure? Will she meet deadlines? Can he work quickly? Will he fit with my current employees? Is she a team player?

| Business Activities Calendar |||| |
|---|---|---|---|

| ←————Prime Hiring Months————→ |||| |
|---|---|---|---|
| JANUARY | FEBRUARY | MARCH | APRIL |

← Grads Enter Market →	←Employee Vacations →		
MAY	JUNE	JULY	AUGUST

←——Prime Hiring Months——→			Holidays
SEPTEMBER	OCTOBER	NOVEMBER	DECEMBER

Every business has unique peaks and valleys of activity.

A client's busy holiday-selling season, for example, might represent a flurry of package design the previous spring.

An easy way to start thinking like an employer is to ask this question: If *you* had to hire a student to earn your course grade in a required design class, who would you choose? The chosen student would attend the class, participate in critiques, take the exams, and execute the projects. At the end of the term the grade would be written after *your* name. What are the qualities you would look for in a student to represent you? In a way, that is what an employer is doing. A new employee represents the employer, is a surrogate for the employer, and earns the employer's grade (income) by satisfying the company's clients. Any hiring decision requires careful consideration.

Joining a Team

Just as a course grade represents all that a student does in the class, so too does the hiring process encompass multiple evaluators. An employer is trying to determine whether a newcomer will fit into an existing, functioning team. This is not just a union of professional skills, but of personal skills as well. Hiring a new employee represents a commitment to eight or more hours each day, five days each week, four weeks each month, and twelve months each year. The employer is evaluating the whole package beginning with the initial contact through to the interview.

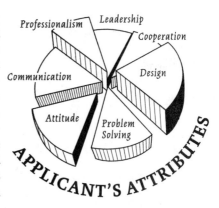

Applying for an entry-level design position is a two-sided process consisting of a series of steps. A prospective employee should prepare with an understanding of the other side's needs and concerns. A balanced approach provides the best chance for landing this first job and, one hopes, initiates a long, successful career in professional design. ✍

CHAPTER 30

CON·
tact

- *First-contact correspondence gives an impression of the applicant's abilities. It functions as a gateway to the rest of the search process.*

*I*t *is easier than ever* to find information about a company or business—how it is organized, what kind of work it does, and what jobs it has available. Internet searches by specific business categories, locations, professional organizations, and more, provide ready access to a wealth of information for job seekers. Finding places to contact is a broad-based effort both online and off—an applicant should look everywhere and tell everyone. Many people hear of leads by word of mouth. How a lead is discovered is not as important as what is done with it.

Both large and small businesses hire designers. From the specialized design firms, advertising agencies, and marketing consultants to the major manufacturing firms, financial institutions, and local health-care facilities, all need to get the word out about their products or services. Where someone secures employment depends on personal preferences and outside influences. A large company composed of all design-related professionals can provide a highly competitive, stimulating environment

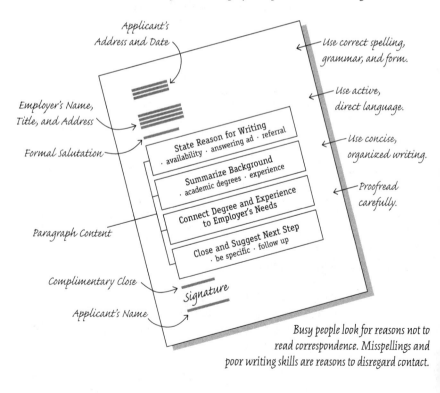

Busy people look for reasons not to read correspondence. Misspellings and poor writing skills are reasons to disregard contact.

and client diversity. A small company or department can offer the designer more responsibility with less client diversity. A wide-open search will identify many possibilities in most regions of the country.

Written Contact

The design field is a competitive one, and first contact (making that first impression) is a must-win step. Written first contact must be perfect and professional—no typos, no misspellings, no grammatical errors, no first-name salutations. The correspondence should contain four points, each in its own paragraph.

Phone contact has a planned purpose. It is not a casual conversation.

-Plan
-Practice
-Take Notes
-Refer

Practice what to say before calling.

Write down person's name, and take notes during conversation.

Employer evaluates conversation for professionalism and communication skills.

Refer to a list of points to cover, previous correspondence, and résumé.

Phone Contact

Phone contact, whether as a follow-up or as first contact, requires planning and practice. Applicants have approximately one minute of uninterrupted time to set the tone and purpose of the exchange while summarizing their experience and abilities. The conversation is professional, businesslike, and to the point with a goal of submitting a **résumé** or securing an interview.

Keeping track of all contacts and how far each one has advanced prevents mistakes, chronicles progress, and limits anxiety. Writing notes on the back of correspondence and keeping a journal are effective record-keeping techniques. Before a follow-up call the applicant should review these notes and all corespondence. When juggling multiple contacts, this is essential. People get one chance to make a first impression; make it a good one. ✍

CHAPTER 31

RÉ·sumé

- *Résumés are typographic documents. They are presentations of facts written in the professional language of the field.*

Type to FAX:
- Not all type faxes well.
- Delicate, hairline strokes and serifs can disappear.
- Typefaces with small counters can plug.

A résumé is a written summary of an applicant's education, experience, and abilities. It consolidates what an employer wants to know at this step of consideration. It is also an example of the applicant's design skills. Creative people evaluate design wherever they see it, even on a résumé. A résumé is mainly a typographic document; concerns regarding prioritizing information, writing, typesetting, and design are pertinent. If the résumé is poorly designed and executed, there is no reason to consider the applicant further.

Design to Deliver

Résumés are delivered to prospective employers in several ways. Each has unique format concerns. A mailed résumé with correspondence should be printed on high-quality paper with matching envelope and letter stock. It is a system, and it makes an impression. A faxed résumé with correspondence should be typeset in a typeface that faxes well. Fax machines vary in quality, and the type of paper is not a factor; however, the résumé's design, quality of writing, organization, content, and typeset execution are under the designer's control. Online delivery of résumés ranges from sending an email with attachment to entering the information in a résumé form provided by the company. Here the typeface and paper are no longer issues, but writing, organization, typing skills, and knowledge of computer formats are. Proof all forms of correspondence carefully with particular attention to online entry; here speed and nerves can open the door to error.

Write for Impact

Résumé writing is concise, to the point, and free from chatty sentences. A résumé contains prescribed categories of information, such as personal identification and contact, education, work experience, special skills, awards, interests (optional), and references. A résumé is not a conversation; it is a presentation of facts. It also demonstrates a command of the professional language. Descriptive, active verbs that present skills in a positive light are more persuasive than passive, lengthy explanations. All date-specific entries are listed in reverse chronological order for quick access to the most pertinent information.

"Designed and maintained company's web site."

more powerful and descriptive than

"Over the course of several months, I worked on the company's web site."

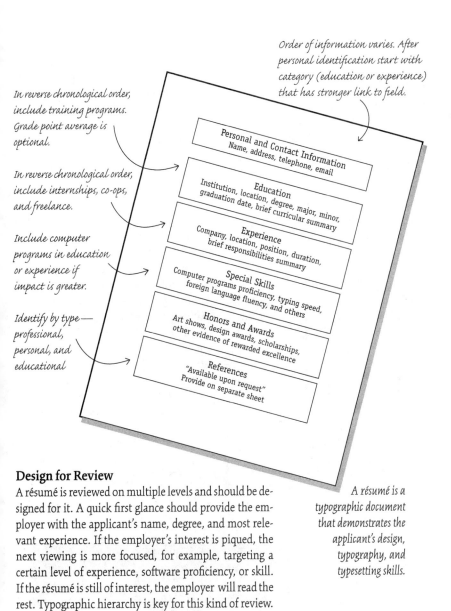

Order of information varies. After personal identification start with category (education or experience) that has stronger link to field.

In reverse chronological order, include training programs. Grade point average is optional.

In reverse chronological order, include internships, co-ops, and freelance.

Include computer programs in education or experience if impact is greater.

Identify by type— professional, personal, and educational

Personal and Contact Information
Name, address, telephone, email

Education
Institution, location, degree, major, minor, graduation date, brief curricular summary

Experience
Company, location, position, duration, brief responsibilities summary

Special Skills
Computer programs proficiency, typing speed, foreign language fluency, and others

Honors and Awards
Art shows, design awards, scholarships, other evidence of rewarded excellence

References
"Available upon request"
Provide on separate sheet

Design for Review

A résumé is reviewed on multiple levels and should be designed for it. A quick first glance should provide the employer with the applicant's name, degree, and most relevant experience. If the employer's interest is piqued, the next viewing is more focused, for example, targeting a certain level of experience, software proficiency, or skill. If the résumé is still of interest, the employer will read the rest. Typographic hierarchy is key for this kind of review.

A résumé is a typographic document that demonstrates the applicant's design, typography, and typesetting skills.

Submitting a résumé is wise with or without an immediate opening. Companies keep résumés on file for future needs. Employees switch jobs for many reasons and two-weeks notice is not much time for a search. With résumés on file, the employer has an existing pool to peruse. Periodically resubmit a résumé to remain in the pool. ✒

CHAPTER 32

PORT·
folio

- *A portfolio is a designed presentation of 15 to 20 projects requiring a total of 20 to 30 minutes to present.*

Some employers prefer to see samples before committing to view an entire portfolio.

Select a size appropriate for the type of work displayed. Small appears more professional and is easier to maneuver.

Portfolios vary in thickness.

Acetate-page portfolios present printouts and printed projects well.

A portfolio is a visual summary of a designer's creative abilities and potential. It is not a lifelong retrospective, but rather an organized sampling of traditional and digital work. The **portfolio** demonstrates an array of skills including design, illustration, typography, drawing, color, finished art, and craftsmanship. Many skills overlap in a single project.

What the Employer Wants to See

An employer looks for many things when reviewing a portfolio. Finding an applicant that matches the job description satisfies the most immediate need. Other issues, however, narrow the field and finally isolate the top candidate. Those issues include creative depth, contribution to expansion of company services, and earning potential.

Successfully demonstrating creative depth quickly elevates one applicant above all the rest. For example, including the creative process for a single project (thumbnails through comp) provides the employer with an illuminating glimpse into the designer's creative abilities. This proves that the portfolio is not just isolated, limited successes, but culled examples from a rich creative crop.

Ways to Organize Portfolio Projects
Specific Skills → Combined Skills
Black-and-White → Color
Simple → Complex

Multiple solutions show creative depth.

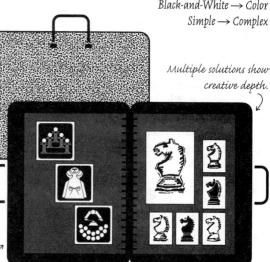

An applicant never knows a company's future plans; they are seldom included in the job description. For example, perhaps the applicant is talented in designing publications and brochures, as stated in the job description, but also demonstrates an aptitude for designing digital presentations. The employer knows that the latter is an area the firm wants to enter eventually, but no one currently on staff is sufficiently knowledgeable. Hiring this applicant enables the firm to develop this new service while filling the original need. Presenting a portfolio that targets the job description, but also demonstrates competency in other areas, elevates the applicant's value to the firm.

Multiple skills are demonstrated in each project. Make sure the portfolio covers all skills appropriate for the position.

Organizing the Portfolio

A portfolio uses select examples to provide a guided tour of a designer's creative skills for a target audience of design professionals. Designers customize a portfolio for each interview. One is comprehensive, equally representative of all of the designer's skills. This is shown when the job description is broad or unknown. Another focuses on a particular skill, such as design or illustration, when the job description is specific. Here the work starts with the identified specialty but ends with a smaller sampling of other skills to show diversity.

Identify with coordinated label.

Design a suitable presentation case for distribution.

Name disc for easy identification with owner.

Test all files before and after creating disc.

Organize portfolio with folders indicating type of work, order to be viewed, or software used.

A digital portfolio demonstrates how well the owner understands and controls this technology.

□ ≡ **Named Portfolio** ≡ 🗗 🗐

7 items, 32.5 MB available

Name	≛
▷ 🗂 1 Résumé, Notes, Refs	▲
▷ 🗂 2 Posters	
▷ 🗂 3 Brochures	
▷ 🗂 4 Illustrations	≣
▷ 🗂 5 Web Pages	▼

There are several ways to organize the projects. The portfolio might begin with simple designs, such as logotypes or symbols, that require minimal explanation. This gives the designer time to get his or her nerves under control before explaining more complicated pieces. For those not adversely affected by nerves, beginning with complicated work can jolt an audience to attention. However the portfolio begins, it proceeds logically through the rest of the work. Linkage between projects can be, for example, by type of work, client, or design style. A portfolio demonstrates all the designer's skills from the overt (design) to the constrained (proofreading). These skills overlap in projects, and using a skills inventory checklist avoids unintentional omissions.

Photographs (printouts, prints, or on-screen images) facilitate presentation of three-dimensional or unwieldy items.

Skills Inventory

☐ Art forms *Traditional and digital thumbnails, layouts, comps, finished art*

☐ Design *Publication, print media, symbols, logotypes, typographic, web, presentation*

☐ Illustration *Line art, vector graphics, bitmapped graphics, markers, colored pencils, varied illustration styles*

☐ Typography *Use of, hierarchy, appropriate selection and size, readability*

☐ Production *Typesetting, color separations,* HTML, *mechanical specifications, file formats and size, photography, scanning, color knowledge and control*

☐ Craftsmanship *Efficiency of digital files, quality of coding, line quality and control, eye for details, workmanship*

☐ Computer programs *Graphics, page layout, digital editing, presentation, website development, techniques*

Portfolio Presentation

Portfolios vary from carry-along leather cases for hand-held viewing to CD portfolios for on-screen viewing or a combination of both. Designers should use whatever format provides the best insight into their abilities. Employers like to see original artwork—the actual digital file or marker-on-board rendering. The employer wants to get inside the work to evaluate work habits, efficiency, and craftsmanship. From the coding for a web site to the number of objects in a vector graphic to the control of markers on layout bond, examples of original art tell much more about an applicant's ability to produce problem-free work than the glossy colored printout alone.

To evaluate the design quality of the work, the employer needs to know some basic information about each project. This project information includes understanding the problem assigned, the restrictions imposed, and the items provided. Without this information the employer is free to make incorrect assumptions about the work and the designer. For example, stating that the illustration was provided by the client eliminates the designer's responsibility for its quality. Pointing out that an ad's photographs were taken by the designer identifies another skill to appraise. Applicants must define their creative involvement and the challenges they faced in order to be accurately evaluated. Notes containing this information should be provided if the portfolio is reviewed without the designer present.

Example of project information for newsletter on page 83.

Project Information Guidelines

1. Identify project *Two-color, four-page, one-fold newsletter*

2. Company name (or equivalent) *Sacramento Lepidoptera Society*

3. Promoted product or service *Flights of Fancy monthly regional newsletter*

4. Target audience *Amateur butterfly collectors and hobbyists*

5. Items provided by client *Type-written articles with identification of major article and suggestions for visuals*

6. Items executed by designer *All text entering and typesetting, illustrations, photographs, layout and typographic design, and nameplate design; provided color-separated finished art to printer*

7. Techniques used *Newsletter executed in QuarkXPress, illustrations in FreeHand, photographs taken with digital camera and edited in Photoshop*

8. Personal note *As an avid gardener before starting this job, I now have an extensive butterfly garden due to information learned from newsletter.*

Blend this information into a one- to two-minute statement about each project.

Presenting a portfolio to someone for the first time should be an enjoyable experience for designers. It is an opportunity to talk about what they love doing, with someone who understands that level of commitment and passion. It is a time to demonstrate a command of the language of the field, as well as an understanding of what all of these techniques and procedures mean and why they are important. Although the first presentation will be the most nerve-racking, future presentations will be easier. As with everything else, practicing the presentation beforehand with a friend will make it smoother in front of the first interviewer. ✍

INTER·
view

- *The interview is an employer-applicant meeting that enables both parties to evaluate abilities, traits, and expectations.*

The interview brings employer and applicant face to face. The applicant who warrants an interview is a strong candidate and now competes with fewer people for the position. Besides demonstrating a strong portfolio with the particular creative skills needed by the company, the applicant is evaluated for professional and personal demeanor, interpersonal skills, professional language, and ability to talk about design. The employer is looking for a person who creates, acts, looks, and speaks confidently in the professional arena.

Interview Preparation

Interview preparation focuses on what to bring, wear, ask, and say. The applicant brings a portfolio of projects appropriate for the position, additional résumés, and a list of references. Being properly prepared demonstrates applicant interest in the position and respect for the interviewer's time. The disorganized, disheveled applicant appears uninterested and not worth further consideration.

What to Wear

Better to dress more formally or conservatively than too casually. The former can be interpreted as a sign of respect or serious intent. The latter can be interpreted as disinterest or immaturity.

Questions to Interviewer
(First Interview)
· Job responsibilities?
· Range of work? · Client contact?
· Equipment and support?
· Travel requirements?

Interview Specifics

An interview is a two-way street. The employer is assessing the applicant according to the company's needs, and the applicant is assessing the employer. To that end, an interview moves from general, get-to-know-you topics to specifics. There are certain facts and skills the employer wants to discuss and to see in the portfolio. There are points that the applicant wants to demonstrate in order for the employer to make an accurate assessment of his or her abilities.

Interviewing for a job is not a passive activity. It is a presentation, a sales pitch, of the applicant—creatively, professionally, and personally. It is not just what is said that conveys these points, but also what is done. All contribute to the total assessment of both parties.

Concluding the Interview

The applicant should be sensitive to when an interview is over. Spoken and body language signify the end of a meeting. Any additional questions should be addressed immediately and then a polite, respectful exit made. The interviewee should ask what to expect next. Knowing, for example, that interviews will continue through the next week alleviates some of the applicant's anxiety, if the awaited phone call is delayed.

After an interview, an applicant should write a note thanking the interviewers for their consideration. This provides an opportunity to supply additional information or to reiterate an important point. It should be a short correspondence, which is unnecessary if the search is moving along quickly. Some business etiquette is regional, and discussions with others can help an applicant to know what is expected.

> **Questions to Applicant**
> · Tell me about yourself.
> · Why the design profession?
> · Strengths? Weaknesses?
> · Why this company?
> · Previous experience?
> · Future goals?

Second Interview

If a second interview occurs, the applicant should inquire about the particulars beforehand. Will new interviewers want to see the same portfolio? Is there an interest in additional work in a specific area? Second interviews are more focused. Compensation, benefits, overtime, advancement, and so forth are discussed with an eye to a final selection. Preparation is important for the satisfaction of all.

> **Questions to Interviewer**
> (Second Interview)
> · Overtime policy and frequency?
> · Advancement opportunities?
> · Salary and benefits?
>
> · Probationary period?
> · Future company growth?
> · Evaluation procedures?

All applicants want to leave an interview satisfied that they have demonstrated their unique skills and abilities thoroughly in the time allotted. In the end, it is up to the employer to decide if these skills are best suited for the job in question. Applicants are not offered every job for which they interview, but they should be content knowing that the employer has what is needed to make a fair, accurate assessment of them. ❧

> **Personal Demeanor**
> · Smile
> · Shake hands
> · Make introductions
> · Say person's name out loud
> · Use professional language
> · Be courteous and sincere
> · Speak clearly
> · Listen

EVAL·
uate

*W*hen the interviews and presentations are over and a job offer secured, the applicant weighs several issues before making a decision. These issues include job responsibilities, working conditions, and financial compensation. Each of these influences the job's total value. The first job an applicant accepts when entering a field is just that—the first, presumably the first in a long line of many. It provides necessary experience and skill enhancement to parlay into succeeding positions of even greater responsibility.

Evaluating job responsibilities involves questions about the type of work the employee is expected to execute. Will it be original design creation or production of someone else's designs? Will the work vary by client, or is there only one client? Is there any possibility of promotion? Will the responsibilities be challenging and require ongoing intellectual and professional growth? The issue of job responsibilities addresses whether employees enhance their professional value for future jobs and feel satisfied doing so.

Conditions of work include everything from the length of the workday (workday plus commute) and the frequency of overtime to the office environment (equipment, space, and furnishings), the frequency of software updates, and the availability of in-house technical support. This issue addresses whether employees feel valued and can execute their responsibilities efficiently and with employer support.

Financial compensation includes not only the size of the paycheck and its frequency, but also the employee's status (full time, part time, or contract) and benefits (medical, personal, bonuses, retirement). The range of compensation gives the applicant an insight into the level of commitment a particular company makes to its employees.

Beginning a career means starting down a path of successive, full-time, field-related positions. Each job entails working with a group of people for an extended period of time while pursuing common goals. A career is woven into the fabric of day-to-day life. No one job is perfect, but the first one has a specific role to play in the larger career mosaic. �££

GLOS·sary

Additive Color Model Creation of color by transmitted light.

Balance A design principle that equalizes the visual impact of an element's attributes on a page containing identical or competing attributes of other elements.

Baseline The invisible line on which typeset letters appear to rest.

Basis Weight Accurate weight measured in pounds that describes a paper's relative thickness within grades.

Bézier Type of mathematics used in graphics software to plot points and their editing handles to create curves and corners to describe a line or path.

Bit Level The amount of color information contained in a single pixel; also known as bit depth.

Bleeds Extension of a printing shape beyond the trim line by ⅛" to ensure printed color up to the trim edge.

Brainstorming Generating ideas for a project quickly without judging quality.

Bulk Measurable thickness of paper; measured in pages per inch or ppi.

Color Systems Sets of spot colors, such as the Pantone Matching System (PMS).

Complementary Colors Colors on opposing sides of the color wheel, such as red and green.

Comprehensive (or comp) The closest visual representation of a design solution before the printed design solution is created.

Continuous-Tone Image Image whose tonal range has smooth transitions from light to dark.

Counter Space in and around a letter.

Crop Marks Thin black lines (approximately ⅝" long) at right angles to one another that indicate the trim edge of a rectangular-shaped printed document, such as a brochure.

Design The process of organizing and prioritizing the visual elements in an image for improved communication.

Die Cut Shaped cutting of a piece of paper, such as *internal* and *external*.

Digitize Description of something in numerical terms.

Display Type Type set 14-points or larger, used for headlines and discontinuous reading.

Drop Cap Enlarged first letter of the first paragraph in a document.

Finish Surface texture of a piece of paper determined during manufacture.

Flexography Relief printing technique using flexible rubber printing plates.

Fold Marks Dashed lines, similar in length to crop marks, that indicate the line along which a printed document folds during production.

Grade Categorization of paper according to an approximate weight range from thin to heavy.

Grain The dominant direction that paper fibers lie in a piece of paper.

Graphic Formatting Creative technique that establishes a visual analogy to explain a complicated concept.

Gravure Intaglio printing technique.

Grid Division of a page into even units used by the designer to establish relationships between the placement of elements on the page.

Halftone Lines of evenly spaced, variable-sized dots that create a reproducible continuous-tone image.

Hue General category color name, such as *red* or *blue*.

Imposition The positioning of artwork on a printing plate for maximum paper usage.

Intaglio Method of printing that uses recessed or incised surfaces to define the inkable (printing) areas.

Intensity Color brightness or purity.

Kerning Adjustment of space between two adjacent letters.

Layout Actual-size sketch of a design idea for client review. The usual step after a thumbnail.

Leading Measurable distance between baselines that includes the size of the type and the white space between the type lines; includes *positive, negative,* and *solid.*

Letterpress Relief printing technique.

Ligature A single-font character created from the physical joining or repositioning of two or three letters for improved letterspacing.

Line Art Simplest form of art composed of a single color image created from solid lines, dots, and shapes; does not contain tonal variations.

Lithography Planographic printing technique originally using flat limestones as printing plates.

Logotype A single word or words designed to be a cohesive, readable typographic design.

Measure The width of a paragraph measured in picas.

Morgue Collection of categorized visual images used by a designer for reference when working on a project.

Newsletter Publication containing written articles and graphics, functioning as a hybrid between a newspaper and a magazine.

Offset Lithography Planographic printing technique that prints the image from printing plate to rubber offset roller and then to paper.

Opacity A sheet of paper's visual density determining whether ink printed on one side shows through to the other.

Operating System Software that regulates the fundamental activities of the computer hardware.

Page Map The visual route the viewer's eye takes through a design.

Photomechanical Reproduction A method of photographically transferring an image to another surface, such as during platemaking.

Pictograms Stylized pictorial images used to communicate a message quickly.

Pixel Smallest unit of a bitmapped image; picture element.

Planographic Method of printing that uses chemicals to distinguish between the inkable and noninkable areas on the same surface.

Portfolio Organized visual documentation of an individual's design skills, capabilities, and experience; the visual equivalent of a résumé.

PostScript Computer language that describes all visual elements on a page.

Process Colors Four colors (cyan, magenta, yellow, and black) reproduced as halftones and printed on a single page creating the illusion of full-color artwork; referred to as CMYK.

Proofreaders' Marks System of text and margin symbols that indicate corrections to typeset text.

Proportion Design principle that focuses on the size relationships between visual elements on a page.

RAM Random Access Memory; a digital space designed for temporary storage of information.

Raster Method to describe computer images as single pixel locations on a grid or bitmap; also called *bitmapped*.

Register Mark Crosshair mark used for accurate color alignment or registration during printing or platemaking.

Relief Method of printing that uses raised surfaces to define the inkable areas.

Resolution Number of pixels in a prescribed area; usually measured in dots (dpi) or pixels (ppi) per inch. Important for determining the clarity of an image.

Résumé Document describing an individual's credentials, including education and professional experience.

Scanner Hardware that digitizes a two- or three-dimensional image or object according to a specified resolution.

Screenprinting Stencil printing technique, such as *silk screening*.

Spot Color Premixed colored ink used for printing.

Spread Two adjacent pages of a book.

Stencil Method of printing that leaves printable areas of a design open so ink can pass through to the paper below.

Stock Paper for printing.

Stylize To design according to a visually distinct and unifying manner.

Subtractive Color Model Creation of color by reflected light.

System Series of unified designs for a single purpose, often referring to designs used to establish a company's identity.

Text Type Type set below 14-points, used for paragraphs and continuous reading.

Thumbnail Quick visual record of a designer's initial ideas in the development of a design.

Tint A lighter version of a color created by reproducing small, evenly spaced dots in the original color. The optical mixing of this small amount of color and the white paper background around it produces the illusion of a lighter color.

Tracking Paragraph-wide adjustment of word and letterspacing.

Trapping Extension of a color into another color to assure the colors properly butt against one another, such as *spread* and *choke*.

Trim Edge The outside edge of a printed document.

Typeface Distinctive, visually unifying design of an alphabet and its punctuation marks and numbers.

Type Family All stylistic variations, such as light, medium, and bold, of a single typeface.

Typesetting The conversion of copy to correct typographic form for the printed or on-screen page.

Unity A design principle that visually joins elements through similarities.

Value The perceived darkness or lightness of a color.

Vector Method to describe objects on the computer as mathematic descriptions; also called *object oriented*.

Web Press Printing press that prints to a continuous roll of paper.

Web Site Series of pages of text and graphic information linked together and accessible through an Internet browser.

IN·dex